W9-CDG-102

I need you to understand something.

I am fighting a kind of loneliness I think we all feel. I think the entire world is desperately alone. I think we get scared when we feel alone and that makes us not trust each other.

I wrote this for you.

I write to the soul of all things in the hope that someone is listening, in the hope that sometimes, I might hear them respond. I'm writing this to feel less alone.

I wrote this for you and only you.

The universe is desperately trying to move you into the only spot that truly belongs to you, in the whole entire thing, a space that only you can stand in. I believe it is up to you to decide every single day whether you are moving towards or away from that spot.
I am trying to draw a map.

Everyone else who reads it, doesn't get it.

Some see gentleness as weakness and sincerity as foolishness.

They may think they get it, but they don't.

Bitterness is not the answer to life. If you think that being unhappy, untrusting and closed off from the world, if you think being cynical about the way the world is and the people in it is a viable strategy for being alive, then someone or something has hurt you and I'm sorry for the hurt that you feel. If they will not apologise for what they've done to you, then I will do it here on their behalf: I am sorry for what was done to you.

This is the sign you've been looking for.

Maybe you didn't know you were looking but I think we're all always looking for something, maybe this is it. And if it isn't, I hope it points you in the right direction.

You were meant to read these words.

All I'm asking is that you trust me for a little while.

Published by Central Avenue Publishing, an imprint of Central Avenue Marketing Ltd.
www.centralavenuepublishing.com

Published in Canada
Printed in United States of America

1. POETRY / General 2. PHOTOGRAPHY / General

Issued in print and electronic formats.
ISBN 978-1-77168-123-0 (paperback)
ISBN 978-1-77168-124-7 (epub)
ISBN 978-1-77168-125-4 (mobi)

Thank you for finding this.

I wrote this for you

2007 - 2017

IAIN S. THOMAS

—

pleasefindthis

central
avenue
publishing

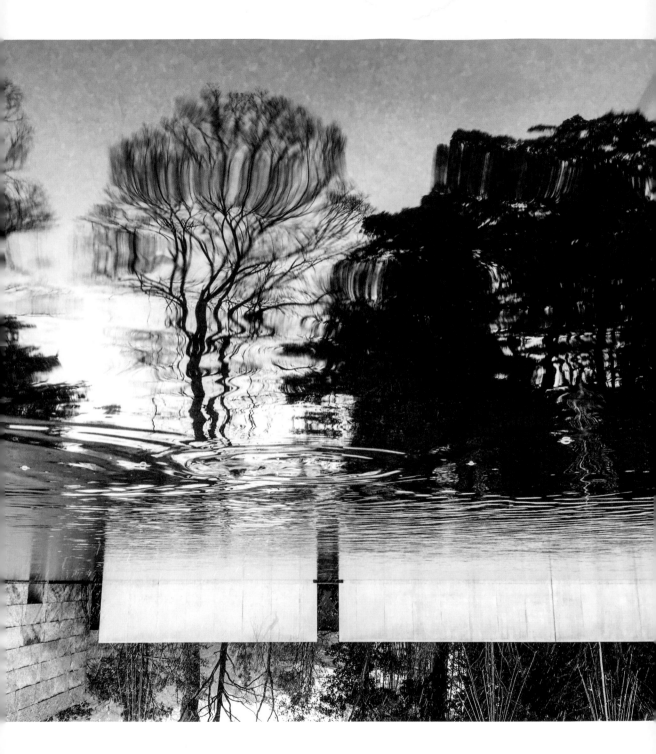

The Start Of All Things

—

Today

Do not start at the beginning.

I am not there.

If you want to understand me, hold me in your hands and think of someone.

And then open me to the heart of me.

Again.

And again.

And again.

Please find me.

You were not put here to impress others, to be better than others or to beat others at all costs.

You were not put here to compare yourself to others and your success is not dependent on someone else's failure.

You were not put here to put others in their place, to teach them a lesson or lecture them about who they are. You can and should help others but don't treat others like they're broken just because they're not who you think they should be - you were not put here to fix others.

You were not put here to rise above others. You are unique but not special and that's not a bad thing because it means all of us can achieve some kind of greatness.

You were not put here to be against others.

You were put here with others.

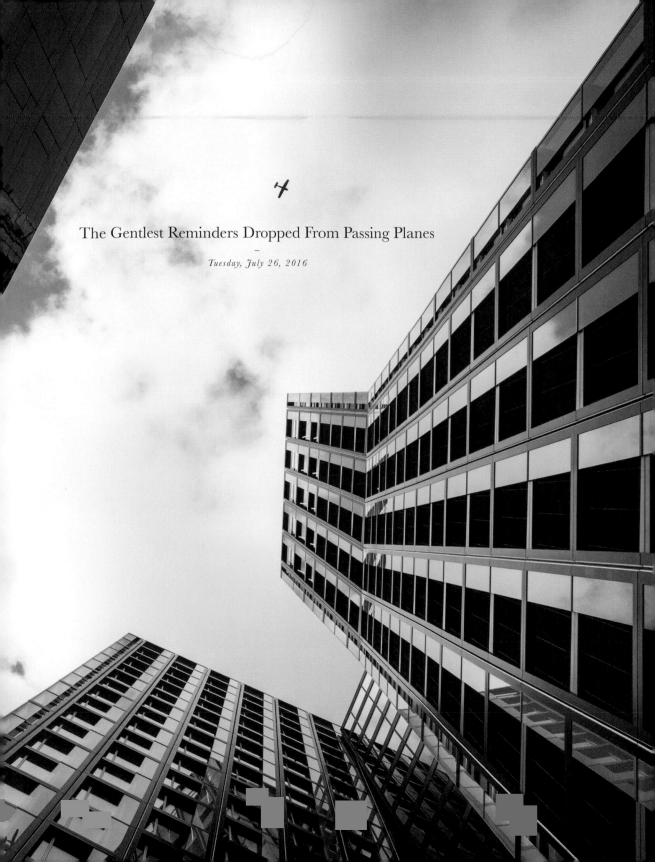

The Gentlest Reminders Dropped From Passing Planes

Tuesday, July 26, 2016

The Taking Of Turns

—

Monday, June 14, 2010

You are in some songs that still get
played on the radio when the DJ is
feeling nostalgic.

You are in a book you once lent me
(never returned) with yellowed pages.

You are in trees when I touch them,
even ones without names carved into
them.

You are in the way someone on the
street laughs as I pass them.

You are in a box I keep filled with
letters.

You are in a ring I no longer wear.

And, every day, you each get a
moment to haunt me.

The Song Across The Wires

—

Friday, April 16, 2010

I'm a picture without a frame.

A poem without a rhyme.

A car with three wheels.

A sun without fire.

I am a gun without bullets.

I am the truth without someone to hear it.

I am a feeling without someone to feel it.

This is who I am.

A mess without you.

Something beautiful with you.

The Sheer Lack Of Existence

Monday, July 4, 2011

I'm made of dreams and memories.

I am made of misheard whispers in the dark.

I am made of glances across crowded rooms.

Of the closeness of strangers in a line outside a movie.

I am made of the corners of your mouth.

I am made of awkward elevator rides and the lack of security one finds on a doorstep, at the end of the evening, when one has enjoyed the company of another.

I am made of the train tracks that take me home.

I am made of ghost notes, from songs you never heard.

So forgive my absence. But I was never really here to begin with, anyway.

The Million Ways To Fail

Tuesday, June 30, 2015

Here's how you fail: You fail with your heart on your sleeve.

You fail like you mean it with every part of you.

You fail attempting the impossible and the ridiculous.

You fail in front of others and you fail and they laugh at you and you fail and you feel nothing and regret less.

You fail sincerely and earnestly and you risk everything at every opportunity.

This is how you fail: You fail beautifully

You fail with grace.

The Hidden Clocks

Monday, November 9, 2015

Don't stop searching.

There is no comfort in giving up.

There are large parts of you that don't exist yet.

The greatest you you could be, is still waiting to be found.

Get up and look.

The Evidence Of History

Wednesday, February 11, 2009

Sometimes I touch the things you
used to touch, looking for echoes of
your fingers.

The Catwalk In The Sky

Sunday, January 17, 2010

And it may look to you like I'm just walking through your city with my head
held high.

But in my head, I am not in your city.

The Sweet Release

Wednesday, May 19, 2010

If you blur your eyes, the streetlights
become hundreds of ghosts going home.

The Things That Might Happen To Us

Thursday, February 16, 2017

I don't understand how you can be so worried about what might happen, when
what might not happen, is so much worse.

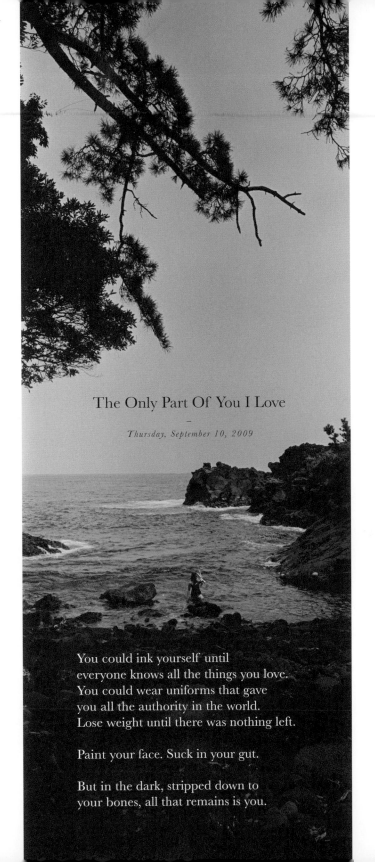

The Only Part Of You I Love

—

Thursday, September 10, 2009

You could ink yourself until
everyone knows all the things you love.
You could wear uniforms that gave
you all the authority in the world.
Lose weight until there was nothing left.

Paint your face. Suck in your gut.

But in the dark, stripped down to
your bones, all that remains is you.

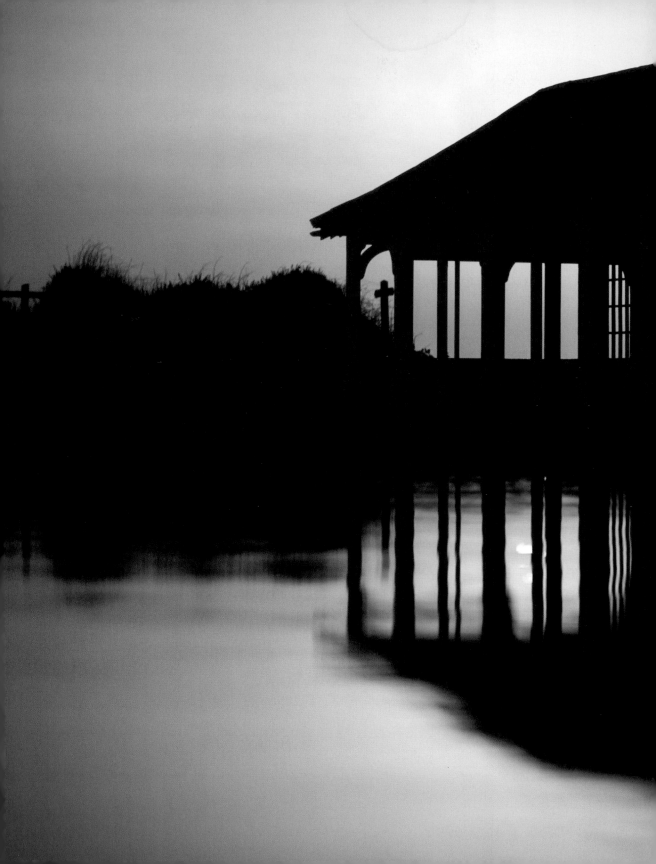

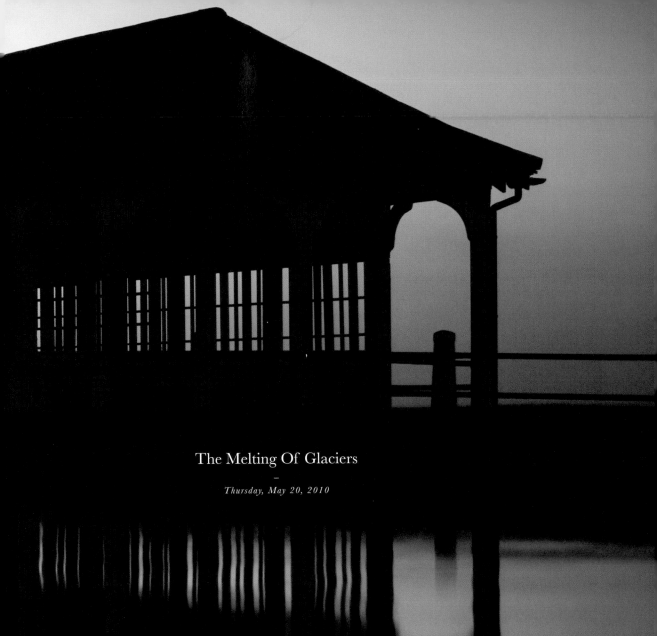

The Melting Of Glaciers

—

Thursday, May 20, 2010

I tried so hard after they left to make
my heart hard. And now you have
undone all my hard work.

The Gods Tremble Before Quiet Strength

Monday, February 6, 2017

I know you best when you are flowers in the barrels of rifles.

I know you best when you are brave.

I know you when your strength comes from your compassion and when your greatest fear, is that you have not been compassionate enough.

I know you when you look at others not as others but as people you might have been, as people your parents might have been, as people your children might still be.

I know you and I see you when you stand up.

I know you and I see you when they tell you to be afraid, to hate, to go away from the world, to go away from each other. I know you and I see you when they scream storms at you, when they bury you beneath mountains, when they drown you in oceans, when they push you under and yet still you whisper from the deepest part of you:

"No."

And when you do, I look at you and I say,

"There you are. I know you."

The Fearful Planet

—

Wednesday, September 21, 2016

Here's the thing you need to remember: People talk about what they fear.

They're afraid you think that they don't make enough money, so they talk about expensive things they've bought or want to buy.

They're afraid you think they're uncultured, so they talk about where they've travelled or show you pictures of the places they've been or want to go, or obscure books they've read, movies they've seen or music they listen to. The important thing here is not that *they* enjoy it, but that *they* know about it and *you* don't.

They're afraid, and so they roll their eyes at the simple things that make other people happy.

They're afraid of what people think of them and so they're afraid of who they're seen talking to.

They're afraid you think they're out of touch and so they absolutely must talk about every new thing they find, as soon as possible.

They're afraid you think they haven't accomplished anything, so they talk about what they're busy with in detail, every chance they get.

They're afraid you think they're ugly and that their life is a mess, so they show you as many photos of themselves looking calm and beautiful as they can.

These are not the actions of brave people.

These are the things you do, when you're afraid.

The Middle Of The Bridge

—

Monday, January 16, 2017

I didn't ask you here so you could like me.

I asked you here so that someone would know who I was.

The Map On My Skin

Wednesday, May 31, 2017

Those aren't scars.

That's where life underlined the
important parts of you.

The Air In My Lungs

Monday, July 5, 2010

When sadness was the sea, you were
the one that taught me to swim.

The Tallness Of Things

Tuesday, May 10, 2011

Falling buildings matter less than you noticing me.
Because the world is big. And here, next to you, I am small.

The Defender Of The Forgotten

Monday, March 8, 2010

You are nobody's hero. And nobody
needs you. Desperately.

The Language Stripped Naked

Wednesday, October 3, 2012

And I'm sorry I ever learned any
words that make you cry.

I'm still doing my best to learn the
ones that make you smile.

The Fog And The Haze

—

Monday, October 13, 2008

Don't say what you say.
Say what you mean.

The Grand Distraction

–

Tuesday, June 19, 2012

And every day,
the world will drag you by the hand,
yelling

This is important!
This is important
And this is important!
And this is important!
You need to worry about
this!

And.
this!

AND THIS!

And each day, it's up to you,
to yank your hand back,
put it on your heart and say,

"No. This is what's important."

The Reversal Of Misfortune

–

Thursday, March 5, 2009

I always thought that I was sick and you were the cure. But everyone gets things backwards sometimes.

The Burning Of Snow

–

Wednesday, March 29, 2017

Tell me again, the story of all the things I cannot do, so I can tell you the story of how I will do them.

The Ghost Train

–

Tuesday, May 26, 2009

And if you can't say yes, answer anyway. Because I'd rather live with the answer than die with the question.

The Protestors In The Park

–

Monday, November 14, 2011

And all around, people fall like leaves in the snow. But those who cut you down, do not know, they are planting a forest.

The Black Ink In Their Eyes

–

Thursday, February 18, 2010

The problem is you think poetry is about words. But the greatest poets I ever met, never wrote a single word.

The Place We Were In

–

Friday, September 26, 2008

And strum my fingers gently across your skin,
like I was playing the slowest love song in the world and
only you and I could hear it.

The Untouchable City

—

Thursday, May 6, 2010

That's what it feels like when you touch me.
Like millions of tiny universes being born
and then dying in the space between your
finger and my skin. Sometimes I forget

The Delusion You Suffer Under

Monday, June 15, 2015

Nowhere on your body and nowhere
on the Earth is it written:

You were made to suffer.

The Apart

Tuesday, April 15, 2008

Avoid people who tell you that you
must live apart from your heart.

Art is found in the heart.

The Orderly Queue

Friday, November 13, 2009

Don't be shy. You can take another piece of me. Everyone else already has.

Until there's nothing left.

Until I disappear.

The Tree In A Forest

Saturday, December 24, 2011

And if you're alone, I hope you know that I'm
alone too. So I believe we will be friends.

P.S. You are beautiful and loved by the universe
that made you, with every atom and star
moving in perfect alignment to make you, you.

The Universe Isn't Open For Business Today

—

Thursday, August 6, 2015

You cannot trade your suffering for less suffering.

The universe isn't open for business today.

You cannot trade the good you do for good done to you, or actual goods of any kind.

You cannot trade your time for more time, you can only sell it once.

You cannot trade your love for love, love is not a transaction.

You cannot trade.

Your money's no good here.

The universe isn't open for business today.

The Ambassador Of Bad Things

—

Monday, February 17, 2014

When something really, really bad happens to you, people will say to you, "I am sorry," even if they had nothing to do with what happened.

And it's because sometimes things happen that are so bad that what they really mean is "I am acting as an ambassador and on behalf of everything that must hurt so much right now, I say sorry."

Because sometimes things are so bad, someone just has to say it.

The Tour Of The
Impenetrable Fortress

–

Friday, October 21, 2011

"What type of building is this? Why would you hide all the beautiful things inside where no one can see them? From the outside, all I see is pipes and bricks, broken and rusted scaffolding, dirt and grime. No one would want to enter this place."

"Because I live inside. And other people, live outside."

The Words Are All In Languages
I Do Not Speak

–

Tuesday, March 6, 2012

And yet, when you get here, you are not given instructions. No one tells you that heart A is meant to slot into heart B. There are no diagrams about how you are meant to live each day or directions on how to assemble some semblance of happiness. You are not even told what colours to paint your feelings or given a purpose and a reason for your life.

You have to make all of it up. You have to make all of it, yourself.

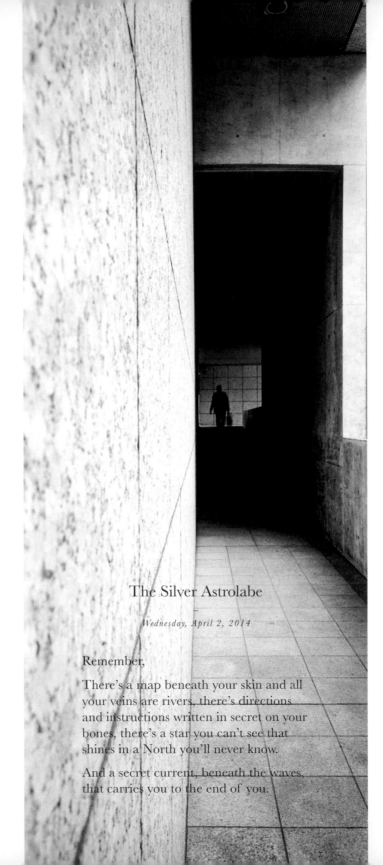

The Silver Astrolabe

Wednesday, April 2, 2014

Remember,

There's a map beneath your skin and all
your veins are rivers, there's directions
and instructions written in secret on your
bones, there's a star you can't see that
shines in a North you'll never know.

And a secret current, beneath the waves,
that carries you to the end of you.

The Animal

Friday, August 3, 2007

*It's when you forget
who you are
that you are most beautiful.*

The Fragile Arc

Monday, July 26, 2010

It may have just been a moment to
you, but it changed every single one
that followed for me.

The Lipstick On The Window

Tuesday, March 23, 2010

The words "I love you" become
nothing but noise. But that's why we
kiss. To say with our lips what we
couldn't before.

The Talk

Thursday, October 25, 2007

The conversation between your
fingers and someone else's skin. This
is the most important discussion you
can ever have.

The Dark Room

Tuesday, November 1, 2011

In this room. With the curtains
drawn. With the lights on. The sun
shining outside. This is where you
hurt the most.

The Remaining Me

Monday, May 7, 2012

Even after the entire world has taken
me apart, there's still a part of me left
for you.

The Art Of Thorns
–
Tuesday, October 6, 2015

One day, you'll realise you can never properly love even one thing, let alone everything.

That's why you get a little sadder as you get older.

You fall in love a little every day with something new, and so your heart breaks a little every day.

The Sun Burns Out
–
Friday, June 3, 2011

I do not know how it ends. Just that I miss you, right before it does.

The Shape Falls At Your Feet
–
Wednesday, February 3, 2010

Maybe it's because you're one of those people that believes that sometimes, the most reckless thing you can do with your heart, is not being reckless with it.

The Person You Aren't
–
Thursday, September 18, 2008

You don't have to be the person you tell people you are. You can just be who you are.

The Silver Lump In My Throat
–
Thursday, July 3, 2014

I hope you know how long it takes me to learn to talk again, whenever you make me forget.

The Refracted Night

Tuesday, June 22, 2010

You forget that, in the dark, we
must move closer together in
order to see each other.
You were never alone.

The Leftovers

Tuesday, February 1, 2011

I made myself from all the love you
no longer wanted.

The New Colour

Tuesday, September 1, 2009

And their shape and their hair and their eyes and their smell and their voice.
That suddenly, these things can exist and you're not quite sure how they existed
without you knowing about them before.

The Stillness Of Patience

Wednesday, December 7, 2011

When you can, let me know how long
you're willing to miss me for.

The World Will End On A Pleasant Day

—

Tuesday, September 27, 2016

You will be wondering why no one picked up the paper
next to the bin, when the missile breaks through the
atmosphere, and whines through the air on its way down.

You will be swimming with friends when the Earth rips
itself open to show the stars its beating heart.

You will be returning something at the store when the men
in lab coats make a terrible mistake with a deadly virus.

You will be looking into the eyes of someone you love and
you will marvel at how the simple act of looking at them
makes you happy and so maybe when the world ends,
you will be ok with it ending.

The Signal Fire
–
Thursday, April 23, 2009

You can never lose yourself so much that I won't find you and remind you of what it felt like to be here.

The Act Of Living Is Lethal
–
Wednesday, January 9, 2013

You forget that even the strongest person to ever live had a weakest day of their life.

The Quiet Room
–
Thursday, October 13, 2016

One day, they will make a public holiday called "The Day Of Saying Things You Did Not Say."

On that day, you will walk into a quiet room and discover someone waiting for you who you have not seen in a long time, and you will be given the chance to say things you did not say during the time you knew them.

This day will be more popular than Christmas.

The Hole In The Sky
–
Friday, April 23, 2010

I'm fine. I just break sometimes. Just understand that if I break, I'm breaking for you.

The Hidden Depths
–
Wednesday, April 4, 2012

You've got to keep looking for them, even after you find them. Otherwise, you lose them.

The Desperate And Confused
–
Wednesday, February 5, 2014

Even if you write down everything that's ever crossed your heart, there will still come a day when none of your words can explain how you feel.

The Forgotten Feeling

—

Friday, November 11, 2011

I know there was something before you.
I just can't remember what it was.

The Purpose Of Love

—

Tuesday, July 24, 2012

When I don't know how I'm supposed
to feel, you're the only person that can
remind me.

The Last Days

—

Monday, April 5, 2010

I just need you to be able to tell people I was here, I felt, I lived and I loved as
much as I could, while I could. And that the person that I loved, was you.

The Blooming Night

—

Monday, April 20, 2009

Late at night, here is
somewhere else. And I
wish I was more than your
emergency contact number
for a broken heart.

The Lantern In The Lifeboat

Wednesday, November 11, 2009

I am nervous. I'm afraid. But I will stand here
in the white hot heat of you. I will play Russian
roulette with your playlists. I will tell jokes I'm
not sure you'll find funny. I will hold on until
there is no more reason to. And in the end, I
will break the stars and resurrect the sun.

The Light Behind Your Eyelids

–

Tuesday, August 19, 2014

In your darkest moments, there are
bright hands reaching for you and a
voice whispering, "Please just open
your eyes and see me."

Even now, I whisper.

The Finite Curve

Monday, November 22, 2010

You will only be hurt a finite number of times during your life.
You have an infinite number of ways to deal with it.

The Sky Is Made Of Wishes

Thursday, December 15, 2011

On other planets, they look up and wish upon you.
Because on other planets, you live on a star.

The Nerve Endings Shatter Like Glass

Thursday, January 10, 2013

It doesn't hurt because if you keep hurting the same part of you
again and again and again, the nerve endings all die. And when that
happens, that part of you goes numb. That's why it doesn't hurt.

Don't be proud of it.

The Title Screen

Monday, February 14, 2011

Just pretend you're in a movie.
Be as brave and as full of love as the main character.
Because we all need to believe in movies, sometimes.

The Medicine Is The Sickness

–

Monday, May 31, 2010

If there's one thing I hate, it's people who won't let me in on the freeway.

If there's one thing I hate, it's having to let people in on the freeway.

If there's one thing I hate, it's waking up to 50 assholes pretending to be me.

If there's one thing I hate, it's waking up feeling like an asshole because I yelled at those assholes.

If there's one thing I hate, it's people who turn the things I say into insipid greeting card messages.

If there's one thing I hate, it's turning a bunch of ideas into a laundry list.

If there's one thing I hate, it's that feeling you get when you scratch something new.

If there's one thing I hate, it's not knowing what's wrong with someone and all you want to do is make them feel better.

If there's one thing I hate, it's knowing that my mind naturally gravitates towards the negative and not being able to stop it.

If there's one thing I hate, it's people who become your friend, to become your friends' friend.

If there's one thing I hate, it's being really busy and using that as an excuse to ignore your email.

If there's one thing I hate, it's having to acknowledge that my feelings are my own, no one else's. And, my responsibility.

If there's one thing I hate, it's forgetting that and taking the way I feel out on the world.

If there's one thing I hate, it's people who criticise things, who can't take criticism.

If there's one thing I hate, it's going to the same job day-after-day for the same pay.

If there's one thing I hate, it's not having a job.

If there's one thing I hate, it's not you.

It's me.

The Chance For Light

Monday, June 27, 2011

No gods or devils. No angels or demons. No group of people controlling the world. Not the greatest person to ever live. Not the worst. Just people. Just a person. Just like you and me.

The Moths Don't Die For Nothing

Friday, June 12, 2009

I'm sure people just kiss each other. I'm sure that sometimes you're talking and somehow two people move closer and closer to each other and then, they just kiss. I'm sure it happens all the time. But I'm also sure that a kiss is never just a kiss.

The Minutes Of The Meeting

Tuesday, June 2, 2009

When you finally understand what it meant, the truth will leave your lips. Not as words. But as a sound at the back of your throat.

The Physics In The Air

Wednesday, June 22, 2011

And I promise you I'll hold your hand. I'll sit back and enjoy it. I'll laugh at lightning. I'll giggle at thunder. I'll drink raindrops. I'll lean into the wind. I'll see the sun come out. And one day, I'll cry for a storm that's passed, never to come again.

The Nothing

Thursday, June 5, 2008

When love begins, it's easy to make something out of nothing.

When it ends, it's much harder to turn that something back into nothing.

The Soft Crackle

—

Thursday, May 8, 2014

Yet love's like a needle on a record, taking parts of you away as it draws sharply and constantly across the heart, in slow descending circles, just to hear a song hidden in the scratches one more time.

The Ugly

—

Monday, August 13, 2007

We were both so ugly inside.
But we made each other beautiful.

The Car In The River

—

Wednesday, June 24, 2009

This is the acceptance speech. The end of anger and denial. I accept that you and I will never be the same again. That while those days will live in my mind forever, they're over. I hate it. But I accept it. And I'm moving on now.

The Whether Weather

—

Monday, June 22, 2009

You think you're waiting for help. For someone to tell you what the right thing to do is. Even though, at the back of your mind, you already know what that is. So all you're really waiting for, is a time when you're forced to do it.

The Same River, Twice

—

Monday, May 26, 2014

Everyone changes so slowly, they don't even know that they have.

And everyone likes to pretend that things are just the same yet they look at you like you could bring something back that's supposed to already be here.

But home is a time. Not just a place.

The World Changed, Not Me

–

Thursday, June 26, 2014

You think I'm unreasonable.

But in an unreasonable world, that's just how I look.

The Point Of Contact

–

Tuesday, September 2, 2008

And then my soul saw you
and it kind of went
"Oh there you are.
I've been looking for you"

The Stones Make Sand Slowly
—
Thursday, January 9, 2014

If you are lucky, one day you'll get the
chance to have your life defined by
how much you loved and were loved
by someone else.

The Passing Of Time
—
Thursday, April 17, 2008

You are an end product of time.
And time will always take its toll.
Never regret the price you pay to
become who you are.

The Aftershock
—
Wednesday, May 6, 2009

But as the rebuilding begins, the memory of you returns. Shaking the
foundations, cracking the walls and spilling what's left of the broken glass into
the street.

The Fire Is Where We're All Born
—
Wednesday, April 29, 2015

All the most beautiful things are pulled from the ground.

All the most beautiful things are made in a fire.

All the most beautiful things are hit again and again.

All the most beautiful things are shaped with hard hands.

Nothing about you is ugly.

You are made of the most beautiful things.

The Fading Glow

Wednesday, May 26, 2010

What you gave me was a reason.
Not an excuse. Because there's sex,
making love and fucking. And then
there's you.

The Space Between

Monday, June 30, 2008

You are the silence between the notes.
The white space between the letters.
The missing that makes everything
else, a something.

The Gun In The Stars

Thursday, September 17, 2009

Out of 1000 hearts, I had to choose
you. One of the comets sent to Earth
to burn brightly, explode and turn to
dust in my atmosphere.

The Far From Home

Sunday, October 12, 2008

I would find you down the line with
broken wings, pick you up, and swear
that you would taste the sky again.

The Fade To Nothing

Wednesday, May 27, 2009

As you drift further into the past, my
memory of you fractures and splinters
until all I can clearly remember is not
a picture but a feeling.

The Dirt Beneath Fingernails

Monday, December 12, 2011

Even though cold is colder. Far is
further. Now is longer. Even though it
takes so long to dig myself out of you.
I still dig.

The World Shoved Me

Wednesday, April 21, 2010

And you can tell when you look at
them that it's everyone else who
made them this way. Or maybe just,
someone else.

The Burning Compass

Thursday, July 22, 2010

My atoms and chemicals could've
been made anywhere in the universe,
but they were made here, near you.
Near yours.

The Shop That Lets You Rent Happiness
—
Tuesday, November 24, 2009

"This is the one," the universe assures me from behind the counter.

"But I thought you said the last one was the one," I reply.

"No," says the universe. "I sold you that one so you would know that this, this is the one."

"Is there another one?" I ask the universe.

"I can't tell you," they reply. "It'd ruin the surprise."

The Arrivals Lounge

Thursday, October 13, 2011

A plane landed and a man in a scruffy coat leaned forward and wondered if this was the one. People got off and walked into the large, gleaming white terminal, where they were either met by others (some in tears but everyone smiling) or if no one was there to greet them, they looked around, shrugged, sat down in one of the long rows of aluminum chairs and either listened to music or read a book or just stared off into the distance in the kind of shell shock that normally comes from long distance travel. Several made phone calls. One, for whatever strange reason, tried to go back through the gate, to get back on the plane. Security, gently, held him at bay.

The old man had seen it all before but he didn't mind waiting. He'd gotten quite good at it. There were exactly 128 chairs in terminal D. The roof had exactly 864 crisscrossing tiles. The planes landed every 11 hours, 59 minutes and 59 seconds. He knew. He'd had enough time to count. He read the paper. It was always the same paper, but each day, there was always a different story about someone he knew on the front page.

Exactly 11 hours, 59 minutes and 59 seconds later, he was too absorbed in the paper and the lullaby of the announcer coming over the terminal speakers to notice the small, diminutive female form standing next to him.

"Hello," she said.

He looked up from his paper.

"I think I know you."

"Yes, I think you do," he replied.

"You once swapped your last packet of cigarettes for a bicycle, in the middle of the war, then rode it for five hours to see me."

"I think that was me. I can't remember. I think we ran a grocery store together. I remember cobblestone streets and a newsagent next door. The children would buy comic books. There was a harbour."

"I think that happened."

There was a silence.

"How was your flight?" he finally asked.

"Good. There was some turbulence towards the end but other than that it was fine."

She rubbed her arms.

"Did you get everything done that you needed to do?"

"Quite a bit. Most of it I think."

"Well, that's all you can really ask for."

"I suppose so. The tea was nice."

"That's good then," he said with a smile.

"Are we supposed to get a taxi now?"

"No, not yet I don't think."

"Then what do we do?"

He cleared some space next to him on the aluminum chair then took his coat off and scrunched it up to make a pillow.

"I think we're meeting someone."

"Oh. Will we have to wait long?"

"No. Not in the greater scheme of things. They serve tea, just ask for one when the woman comes round with the tray."

"Is it good?"

"The best you've ever tasted."

By the time the next plane landed, she'd fallen asleep on his shoulder.

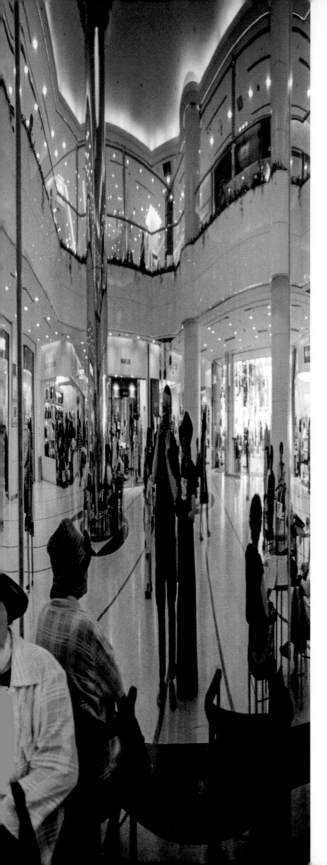

The Way Glass Breaks

—

Monday, February 7, 2011

This is the song I only sing when you're sleeping. These are the words I say when you can't hear me. This is the way I look when you can't see me. And you will never know.

The Sparks In The Ceiling

—

Monday, August 24, 2009

The sky was made so clear that sometimes, at night, you can see the far blue edge of forever behind distant suns. Yet, nothing's that clear here, and I'm sitting right next to you.

The Lack Of Apologies

—

Friday, May 15, 2009

No matter how you stack me. No matter how you arrange me. No matter how you look at me. I am still here and I am still the same person made of the same things. I regret nothing.

The Distance From Here To Autumn

—

Monday, July 19, 2010

I wondered if every road was connected to every other road. I wondered if I touched it, if maybe somewhere, you would know.

The Best Of Us

—

Tuesday, February 7, 2017

I whisper because some part of me wants you to whisper too.

Because I want you to tell me secrets.

Because sometimes, our secrets are the best parts of us.

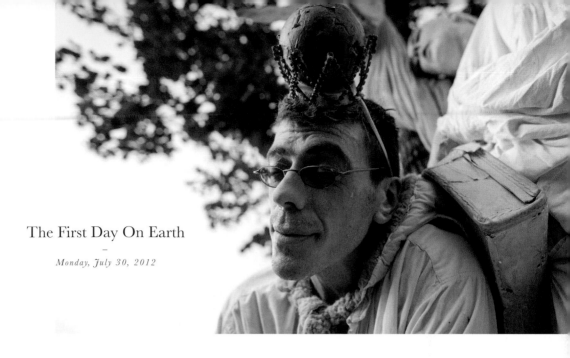

The First Day On Earth

—

Monday, July 30, 2012

Firstly, you need to relax. I know it's not as warm as it once was but you get used to the cold and warmth can be found in the people around you. Secondly, do not get used to crying to get things. Some people never grow out of it. Avoid them. Spend time around people who smile in the face of despair. Learn from them all you can. Everyone is a lesson. A story. A unique and wondrous perspective on the chaos that is human existence. The more people you talk to, the more you understand it. But never speak if you have the opportunity to listen. Especially if you want someone to like you. There's nothing you can say that'll endear someone to you as much as really and truly listening to them. You are on day one of a sometimes remarkable, sometimes terrible, sometimes beautiful, strange and always completely unknown journey. Be ok with this. Worrying about what happens next will ruin the surprise. You will meet strange people along the way, some good, some bad. This is a pattern that will more than likely repeat constantly as you grow up. Some things will be good, some things will be bad. Neither will ever last forever. Nothing will stay the same. Appreciate every moment of happiness and remember it when you despair. Hold them close. And when you are happy, remember the moments of despair and think to yourself, "I told you so." Never let someone else define you. You are your own creation and only you decide how you feel, who you are and what you want. This can be scary at first but it is liberating to truly and utterly embrace your own identity. People who hate you for not being like them are not worth hating back. Please, let go of hate whenever you can. Accept love whenever it is given and give it out freely. It is the most powerful force on Earth.

Enjoy your stay.

The Reflection In Someone Else's Eyes
—
Monday, September 7, 2015

There is an innocent but selfish part of you that wants to love and be loved because you know being loved will make you want to be worthy of being loved.

There is a part of you that just wants to see the kind of person you could be, through someone else's eyes.

The Strange Reflections
—
Monday, October 31, 2016

Somehow, the worst that could happen, is both seeing you and never seeing you again.

The Shapes Left Behind
—
Tuesday, December 3, 2013

You should not look for me in the places I once was. Look for me in the places I am now. In soft rain.

On starlit oceans.

The Mist Descends
—
Monday, October 3, 2011

If you think I can tell you what's going on inside my heart, you know even less about it than you think.

The Importance Of Breaking Things And People
—
Friday, March 16, 2012

Just so you know, there are certain people who were put here to break you.

So you could learn how to pull yourself back together again.

The Circus Is Cheaper When It Rains

Wednesday, July 7, 2010

I've taken the same ride too many times.

I could fall asleep in the loop.

I know the clowns wipe the fake, makeup smiles off their faces once the show is done.

I know the lions sleep in cages at night.

I know the tightrope walkers have blisters on their feet.

I know the ringmaster doesn't believe in what he yells to the crowd anymore.

I know the strongman, isn't as strong as he once was.

I know the candy floss has always been, just sugar and air.

You are the only reason I come back here every night.

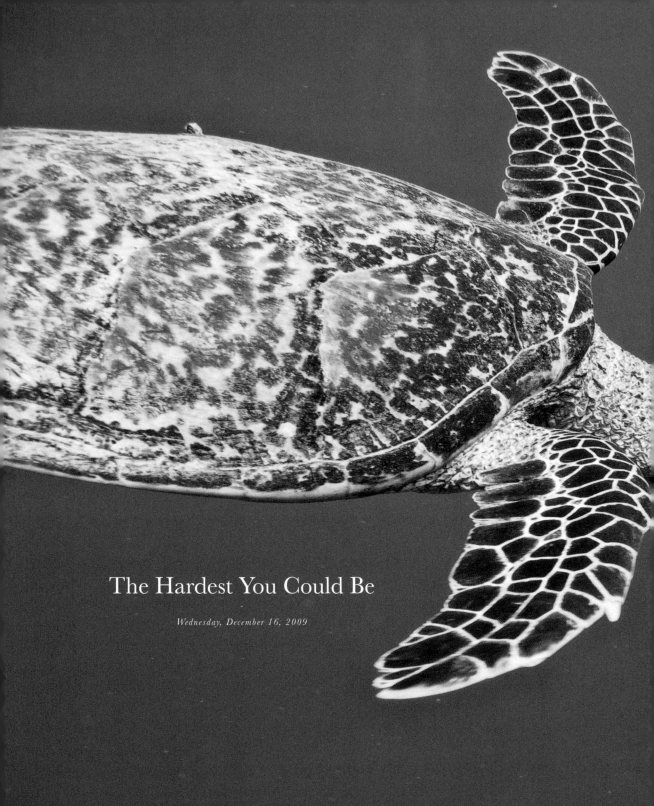

The Hardest You Could Be

Wednesday, December 16, 2009

And you will find no fear here, in unkind
words or the hardness of others.

And you will find no sadness here, in the
meanness of the world, in the anger that
comes from those who feel small.

And you will find no hurt here, in a million
insults or a single, softly spoken lie.

Because only a hard heart shatters.

Only a hard heart, breaks.

The Ship Made Of Broken Parts Can Still Go Anywhere

—

Monday, September 17, 2012

You only fix the things you feel deserve to be fixed, as if you're a special kind of person who doesn't deserve to sort their own life out because of who they are. Like your brokenness is a symptom of being you.

"I can let that wait, I don't need to do this because I don't deserve to have it done. My life is always only ever incomplete."

And yet, no one deserves the full benefit of being you, more than you.

The Anxiety Inherent In Air

—

Thursday, June 5, 2014

If you must know, this is what I'm scared of. I'm scared that everyone else is more who they are than I am who I am. I think everyone else just looks at the things they feel or think and says, "Of course this is what I feel or think, this is who I am."

But I am never sure of what I feel or think.

And I'm scared because I'm holding all the things I could feel or think on a boat that the slightest breeze could tip over and if that happens, I will fall with all of it into the water. I am scared I will be left with nothing and no idea who I am.

I am scared of the wind.

The Day Time Waited For Me

–

Monday, May 10, 2010

And so, I wait because you have already
left and my work here, is done. I wait
and wonder how my skin feels like it's
made of love letters written a hundred
years too soon (too late). I wonder at
the mystery of life and how much of it
can possibly remain. I wonder at pain
and hurt and love and time and how
much of each I held. I wonder at how
I cannot remember anything in my
life before I met you. I wonder at the
tiniest of touches and try, desperately,
to keep their memories alive. I wonder
at loneliness. I wonder at how long it'll
be, before I see you again. I wait. And
I wonder.

The Rules Of Engagement

–

Thursday, August 13, 2009

All persons entering a heart do so at
their own risk. Management can and
will be held responsible for any loss,
love, theft, ambition or personal injury.
Please take care of your belongings.
Please take care of the way you look at
me. No roller skating, kissing, smoking,
fingers through hair, 3am phone calls,
stained letters, littering, unfeeling
feelings, a smell left on a pillow, doors
slammed, lyrics whispered, or loitering.

Thank you.

The Gone

–

Saturday, November 17, 2007

When they are gone, you will remember every single opportunity you had to speak to them. And didn't.

The Haunted Quiet

–

Tuesday, August 25, 2015

You're wrong. Happiness isn't forgetting. Happiness is finding new things to remember.

The Flanking Positions

–

Sunday, May 10, 2009

Let them hate you but let it be because you are a good person in a bad world and bad always hates good.

The Worst I've Felt

–

Tuesday, May 17, 2011

You'll kiss them, even though you can see they're sick. Even though you know they'll make you sick.

The B Train

–

Monday, August 9, 2010

I'd leave the memory of you at the station, if it didn't already know the way home.

The Screaming Mob

–

Friday, July 24, 2009

People will wish you all the success in the world. And then hate you when you get it.

before there was music you were the first reason to sing

The Story Can Neither Be Created Nor Destroyed

Thursday, October 25, 2012

As you fall, remember that you are part of a beautiful story that did not start when you were born.

Remember that you are the universe exhaling, a breeze waiting to blow across a field of tall grass.

Remember, you are part of a beautiful story that did not start when you were born.

As your body cuts through the air, think of only the things that made you smile, the people that made you love, the ideas that made you strong.

Remember, those things will never happen again but they cannot unhappen.

Remember, you are part of a beautiful story that did not start when you were born.

Remember, what you felt can't ever be taken away.

Remember, you are part of a beautiful story that did not start when you were born.

And it will not end when you die.

Remember.

The Children Of Time

—

Tuesday, April 27, 2010

January has issues with her mother, February is always
talking about things he wants to do while March does
them, April eats sweets and May pays for them, June is the
oldest but not the wisest and July always has an opinion on
everything. August never stops trying do the right thing,
even if he doesn't always know what that is. September once
saw something so sad, she never stopped crying. October
holds the lift for anyone, vice-presidents and street-sweepers
alike (for his memory, not for theirs) and November makes
fun of him for this. December is tired but always hopeful.
He has never once stopped believing.

Monday's obviously a bastard, quite literally as dad
can't remember what or who he was doing. Tuesday's
temperamental but ok as long as you stay on her good side.
Wednesday doesn't say much and Thursday sometimes
hums just to break the silence. They're in love. Friday's
always wasted and she and Saturday hold each other tightly
until their delirium fades.

But Sunday, Sunday knows she's the end. But she closes her
eyes, and she pretends with all the strength in her tiny heart
that really, she's the dawn.

The Last Land I Stood On

—

Monday, August 6, 2012

And my fingers are ships sailing on your
skin, slowly drifting and hoping against
hope that they fall off the edge of the
Earth.

And your heart is nothing but the gravity
pulling me towards you.

The Missing Exclamation Marks

Monday, November 23, 2009

You're ok. Breathe. Just breathe. Open your eyes. Come back. It's ok.
It's over now. You're ok. Wake up. Please wake up. Don't do this to me.
Don't do this to me. Don't do this to me. I love you so fucking much.
Come back.

The Moments That Matter

Thursday, December 1, 2016

Remember the person that you are, in
the moments that you aren't.

The Heart Cannot Be Discounted

Monday, September 3, 2012

If they put you back on the shelf, in exchange for someone else, don't worry.

I promise: Someone better's coming along.

The Complications Start With You

Tuesday, April 29, 2014

Here is the simple truth about people:

Love the ones you want to keep.

The Craft

Monday, September 17, 2007

Science and art. Washing dishes and adding numbers. Driving taxis and sailing
ships. Find what you love. It doesn't matter what it is or how much money you'll
make or what people will think of you. Just find it and hold on tightly.

The Secret Zodiac

Tuesday, January 13, 2015

The stars that guide you might be too far away to ever see.

Maybe there's some bright, secret sunlight somewhere in the universe that understands you, and knows what's going on.

The Sky Has Weight

Monday, May 25, 2015

If you carry someone in your heart for too long, it will become heavy.

The Few And The Fewer

Tuesday, July 6, 2010

You can make the world beautiful just by refusing to lie about it.

The View From The Hospital
—
Wednesday, January 4, 2012

If you can't let go, you can't put your
heart back in your chest.

The Lying Tree
—
Thursday, March 3, 2011

The least you could do, is uncross
your heart. Unhope to die.

The Future Is The Past Waiting To Happen
—
Friday, August 13, 2010

And though you may not be able to imagine what I
was like, I did live. More importantly, I loved.

The Perfect Kiss

—

Friday, October 16, 2009

Which is when the world stopped turning.

Which is when the birds fell silent.

Which is when the clouds all breathed in at the same time.

Which is when lies became truth.

Which is when pain became love.

Which is when fires burned blue.

Which is when red flowers bloomed.

Which is when snow fell.

Which is when ice became water.

Which is when the universe smiled.

Which is when the sunshine and the moonlight met.

Which is when gravity gave up the ghost.

Which is when the air became thick.

Which is when people screamed at the edges of cliffs.

Which is when every guitar in the world strummed the same three chords over and over.

Which is when the dead rolled over and wished to live again.

Which is when the song turned itself up.

Which is when aliens on other worlds looked up into the heavens and gasped.

Which is when hurricanes and storms and floods swept through us.

Which is when tears fell from willows at the beauty of it all.

Which is when riots and madness chased themselves through the streets.

Which is when millions of glasses committed suicide, throwing themselves from kitchen cupboards.

Which is when angels were filled with envy.

Which is when vampires threw back their heads and howled.

Which is when skin crawled.

Which is when we were watching TV on a couch.

Which is when you were in my arms and my tongue was in your mouth.

The Bibliography Of Strings

—

Monday, August 10, 2009

And you taught me what this feels like.

And then how it feels to lose it.

And you showed me who I wanted.

And then who I wasn't.

And you ticked every box.

And then drew a line.

And you weren't mine to begin with.

And then not to end with.

And you looked like everything I wanted.

And then became something I hated.

And you get thought of every day.

And then not in a good way.

And you let me leave.

And then wish I'd stayed.

And you almost killed me.

But I didn't die.

The Peace And The Star

—

Wednesday, October 21, 2009

You think bravery is to fight and courage is to die.
But the bravest ones stand in front of those who
would die and say,

"We will not fight. Because courage is to live."

The Forgotten Star

Wednesday, February 17, 2010

You keep telling me to be glad for what we had while we had it. That the brightest flame burns quickest.

Which means you saw us as a candle. And I saw us as the sun.

The Strangest Books

Friday, May 6, 2011

You've written my story backwards.
You've taken my chapter out of your
book. Now I'm just a prologue.
A dedication.

"For you."

The Glassy Reflection

Monday, November 3, 2014

If I'm loud, it's because I'm above
the wave and if you can't hear me,
it's because I'm under it. And I never
want you to worry because the nature
of a wave, is to pass.

The Limited Opportunity

Monday, August 13, 2012

There are only so many of us born at a time and we are thrown into the world to find each other, to find the other ones who don't think you're strange, who understand your jokes, your smile, the way you talk.

There are only so many of us born at a time and we only have so long to find each other before we die.

But we have to try.

The 10000 Ton Grave

—

Monday, March 20, 2017

"What I'm saying is I don't want you hurting somewhere when you least expect it. I don't want you ordering coffee and waiting and suddenly feeling sad and lonely out of nowhere. That's why I'm saying we should bury them deep, these people that we were and the things that we had, and far away from each other. I don't want them finding each other again, in the ground beneath us. I don't want you to hurt again and I don't want to hurt either and as near as I can tell, that's all we can do for each other."

The Wishing Well In The Sky (Letters To Father Time)

–

Friday, March 26, 2010

All I ask is that you let me spend forever feeling this way, before you take me.

The Fight Eternal

–

Tuesday, May 3, 2016

You would destroy us, for something as useless as being right.

The Metal Starts To Twist
—
Wednesday, April 8, 2009

I'm lost and looking for the sky,
for moving parts and a place
that doesn't rust. For wheels
that burn and a world that
turns. For a road that phantom
cars still drive down while
lovers long lost feel wind that's
blown too long in silver hair.

You are the only map I know.

The Echoes In My Skull
—
Wednesday, October 19, 2016

After everything, you will
discover that loneliness is just
not finding yourself, because
there's no one around to find
yourself in.

(You will discover: we need
someone else to see us, to be
able to see ourselves.)

The Mirror Hurts
—
Thursday, July 15, 2010

I never heard what you said,
just what you meant:

I hate you.

I love you.

I don't love you anymore.

The More Than Three
—
Thursday, December 18, 2008

Wish you were here.
Wish I was there.
Wish it was different.
Wish wishes came true.

I'd wish you back.

The Clearest Lens
—
Thursday, June 14, 2012

And may you never wish
that life would pass with
background music in a black
and white montage. And may
you lust and hunger for every
awkward second of real life, in
all its un-retouched glory.

The Town At The Time
—
Monday, February 9, 2009

Between you and me, this is
where we buried the people we
once were, and the people we
could've been.

The Day You Read This

—

Friday, September 26, 2008

On this day, you read something that moved you and made you realise there were no more fears to fear. No tears to cry. No head to hang in shame. That every time you thought you'd offended someone, it was all just in your head and really, they love you with all their heart and nothing will ever change that. That everyone and everything lives on inside you. That that doesn't make any of it any less real.

That soft touches will change you and stay with you longer than hard ones.

That being alone means you're free. That old lovers miss you and new lovers want you and the one you're with is the one you're meant to be with. That the tingles running down your arms are angel feathers and they whisper in your ear, constantly, if you choose to hear them. That everything you want to happen, will happen, if you decide you want it enough. That every time you think a sad thought, you can think a happy one instead.

That you control that completely.

That the people who make you laugh are more beautiful than beautiful people. That you laugh more than you cry. That crying is good for you. That the people you hate wish you would stop and you do too.

That your friends are reflections of the best parts of you. That you are more than the sum total of the things you know and how you react to them. That dancing is sometimes more important than listening to the music.

That the most embarrassing, awkward moments of your life are only remembered by you and no one else. That no one judges you when you walk into a room and all they really want to know, is if you're judging them. That what you make and what you do with your time is more important than you'll ever fathom and should be treated as such. That the difference between a job and art is passion. That neither defines who you are. That talking to strangers is how you make friends.

That bad days end but a smile can go around the world. That life contradicts itself, constantly. That that's why it's worth living.

That the difference between pain and love is time. That love is only as real as you want it to be. That if you feel good, you look good but it doesn't always work the other way around.

That the sun will rise each day and it's up to you each day if you match it. That nothing matters up until this point. That what you decide now, in this moment, will change the future. Forever. That rain is beautiful.

And so are you.

The Waves Put You To Sleep
–
Friday, June 29, 2012

I love you like I love the sea. And I'm ok
with drowning.

The Ebb And Flow
–
Tuesday, September 7, 2010

I know I'm only borrowing it. I know I
have to give Summer back to you. Just as
you have to give Winter, back to me.

The Anchor
–
Tuesday, September 25, 2007

Hold the peace inside yourself. Do not let
it depend on other people, the day you're
having, the work you have to do or any of
the other flotsam and jetsam of life.
Let it depend on you and the choice you
make to feel it.

The Words That Leave On Last Breaths
–
Monday, February 24, 2014

Sometimes I wonder if you've only got a certain number of words
and sentences in your head and if you use them all up, you get quiet.

Maybe that's why the young have so much to say, while the old hold
what little words they have left so close and so tightly in their hearts.

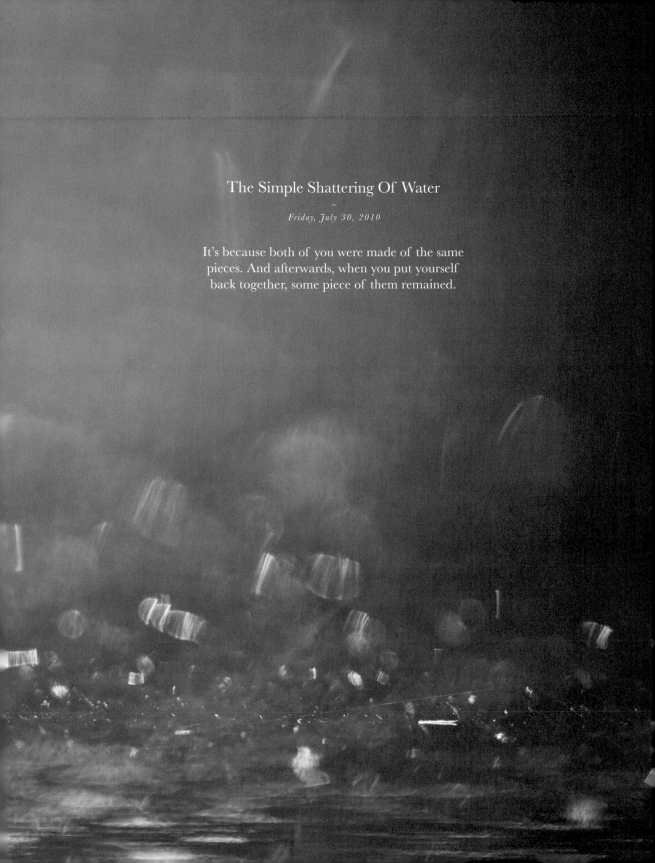

The Simple Shattering Of Water

—

Friday, July 30, 2010

It's because both of you were made of the same pieces. And afterwards, when you put yourself back together, some piece of them remained.

The Objection Your Honour

—

Friday, April 25, 2014

Just then, right in the middle of the brilliant monologue your defence attorney is delivering about all the things you've done and all the people who love you, the prosecution slides a note over to you, "Don't ever forget, everybody hates you."

You add it to the pile of notes he's already given you, which read:

"No one will ever understand you in the way that you desperately want them to understand you."

"You will watch all your favourite musicians kill themselves and all your movie stars will grow old."

"Everything you've ever made has been trite and cliche and horrible. In fact anyone who's ever said they've liked anything of yours has done so out of pity."

"One day you and someone you love will find yourself in a room and one of you will be dead and the other will wish they were."

All of which he will later enter as Exhibit B in the long, drawn out court case to convict you of being simply pathetic and sad and useless at everything, really.

And yet your defence attorney carries on. And you know that sometimes, he's fighting for your life.

The Map Of Imperfections

—

Saturday, October 18, 2014

I am a record of things I was born with.

These scars are my documentation of the mistakes I've made in trying to overcome them.

I am both the things I've done to myself and the things done to me.

Along these nerve endings, you will find a history of me.

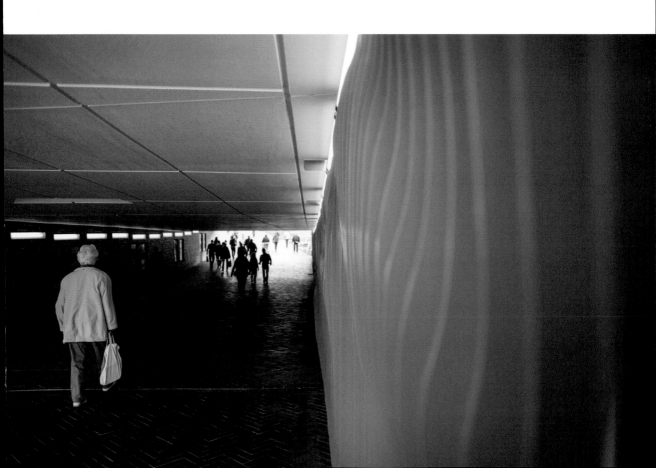

The Sea Reclaims The Land
—
Monday, September 13, 2010

I know you're just a rag doll now, sewn together with memories that we might have had.

I know you're just the dream inside of a dream.

And don't worry, I know I don't know you, anymore.

The Hands Upon You
—
Sunday, April 5, 2009

Small people only want one thing from you:

Someone else to be as small as they are.

Stay big.

The Tick-Tock In Your Chest
—
Wednesday, February 24, 2010

I will hold you so tightly and carefully when I see you again. Like crystal. Or an atom bomb.

The Return To Green

Friday, August 21, 2009

Oh shut up. Every time it rains, it stops raining.
Every time you hurt, you heal. After darkness, there
is always light and you get reminded of this every
morning but still you choose to believe that the
night will last forever. Nothing lasts forever. Not the
good or the bad. So you might as well smile while
you're here.

The Way It Rains Down Windows

Sunday, March 1, 2009

And there are thousands in the crowd outside every
day. And everyone's there. And they love me. And I
don't care. Because they're not you.

The Grim Alternatives

Wednesday, April 15, 2009

I love no one but you, I have discovered, but you are
far away and I am here alone. Then this is my life
and maybe, however unlikely, I'll find my way back
there. Or maybe, one day, I'll settle for second best.
And on that same day, hell will freeze over, the sun
will burn out and the stars will fall from the sky.

The Away Team
–
Tuesday, May 24, 2016

You were the only one who knew me.

The Tired Advice
—
Tuesday, November 11, 2008

But love is none of these things. It won't suddenly make every day ok.
It won't change who you are. It won't make your car go faster.
It doesn't even wash your dishes.

All love is, is love. And that's all it needs to be, really.

The Middle Of The Universe
—
Wednesday, April 25, 2012

I understand that you care. I just
sometimes feel that the people who know
me best, are people I've never met.

The Monsters Are My Friends
—
Thursday, July 2, 2015

I want someone to lean across one day and say, don't you hate it when
everything's really beautiful and it hurts at the same time, so I can say, yes, I
hate it. Then me and them belong to a club, and we are never, ever alone again.

There are clubs, everywhere, that I don't belong to.

The Fine Art Of Longing
—
Wednesday, May 13, 2009

I was so busy missing you, I missed
someone else standing right in front of
me. Now I'm missing them instead.

The Dead Sunwheels
—
Thursday, February 5, 2009

You'll be as shocked as I was to discover that their last words weren't,

"Did everybody like me? Did I like the right music? Were enough people attracted to me?
How did people feel about my decisions? You don't think I upset anyone do you?"

The Final Exam

—

Tuesday, January 24, 2012

a) Rain is the sound of the night rolling over in its sleep.

b) Rain is a record of broken promises and each one is sent back to Earth to clean it.

c) Rain is life by a 1000 cuts.

d) Rain is a coronary anesthetic.

e) Rain is the world secretly crying for you, when no one else will.

The Place Where You Get Off

Monday, February 8, 2010

Outside the station, she stands with her child on the side of the street, taking pictures of cars.

You think she's insane. Until, one day, you notice that she's taking pictures of the license plates of the cars her child gets into.

Because you look. But you do not see.

And she walks out of the shop with bags full of cat food. You think she's some crazy cat lady until you find out, she has no cats.

Because you eat. But you do not taste.

It's been a while since their last album but he assures you, he's doing just fine these days, white flecks in his nostrils. Then he asks you if he can spend the night on your couch, even though it stinks.

Because you sniff. But you do not smell.

And they say, "Just OK," when you ask them how school was. Then you wonder what they're hiding until you find their diary and the last entry reads, "I wish you'd give me some privacy."

Because you listen. But you do not hear.

And they've got a bruise over their eye and you run the tips of your fingers over it and ask them how it happened. You believe them. Until it happens again.

Because you touch. But you do not feel.

And they walk past you every day, one million stories, each waiting to be told. Waiting for you to ask.

Because you live. But very few, love.

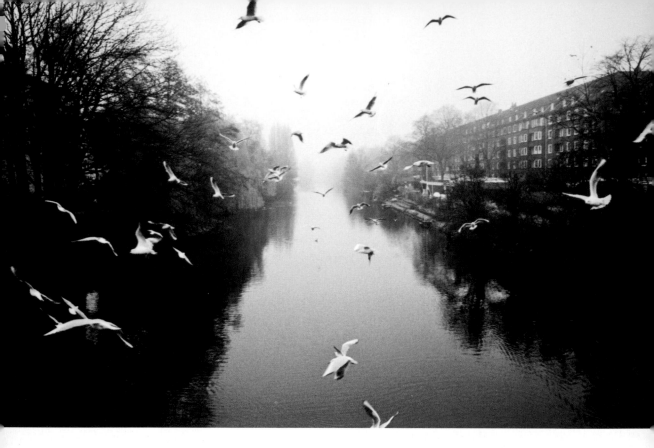

The Ripple In The Clouds

—

Thursday, November 28, 2013

The hardest thing to do when you go back
underwater, is talk about what the sky was like.

The Seraphim And The Pirate

Tuesday, June 15, 2010

You were better to the ones that were worse for
you. And worse to the one that was better for you.

The Leaves As Ashes

–

Monday, July 14, 2014

I used to think that when you got old, you envied the young. But now I see
that you only ever envy yourself and who you used to be. You only ever look
at young people and wonder how you survived all that.

The Envy Of A Billion Little Unique Snowflakes

Tuesday, April 17, 2012

I don't care what people think. I fell in love with you. Not people.

The Things I Have Felt Have Torn Me Apart

Wednesday, February 1, 2012

Those who walk away from you in the dark
should be forgotten in the light.

The Time

Wednesday, July 11, 2007

Times will be tough like old leather and gravel roads occasionally.
Times will be easy, like Sunday morning, every now and then.
What you do during these times will define you as a person and a
human being. Your humanity towards others, your will to make
the world a better place for you and those around you and your
identity as a citizen of the world. All these things count.

The Grinning Fool

Tuesday, February 21, 2012

Each night, somewhere out there, people go to bed, petrified that
I might be happy as I am.

And I wake up each day and make their worst fears come true.

P.S. I hope you're happy.

The Dream Of Trees

—

Thursday, April 14, 2016

Everyone forgets how to fall asleep sometimes.

You just put your head on the pillow, and breathe out like you're giving up.

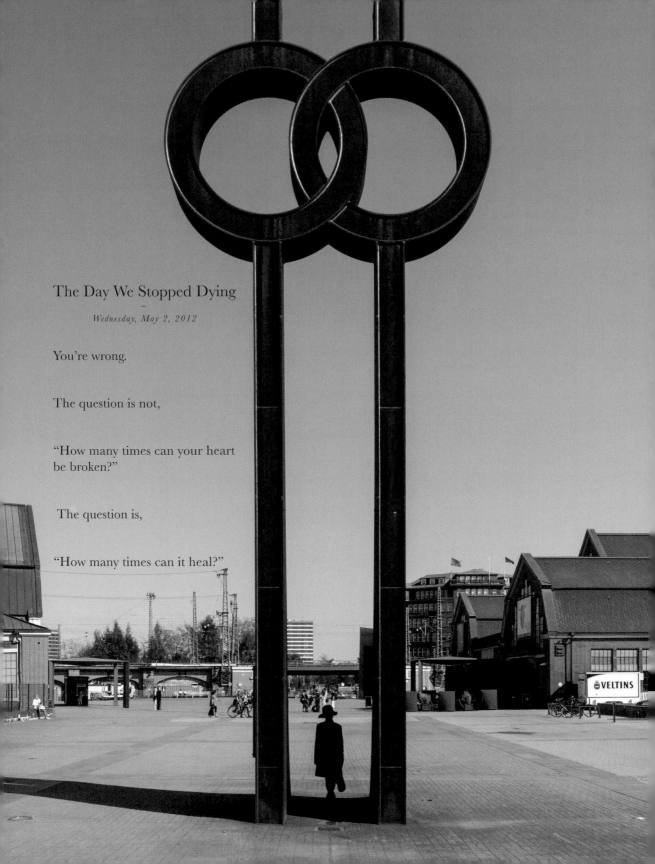

The Day We Stopped Dying

Wednesday, May 2, 2012

You're wrong.

The question is not,

"How many times can your heart
be broken?"

The question is,

"How many times can it heal?"

The Life And Death Of Most Of Us

Thursday, February 26, 2015

Most of us will settle for fine.

Most of us will stream mp3s instead of asking a friend to play the guitar.

Most of us will run on a treadmill at the gym instead of going to the park.

Most of us will watch 10 second videos on a computer instead of going to a play.

Most of us will eat something we can throw in the microwave instead of learning to cook.

Most of us will aspire to being known, to being famous for just a little while.

Most of us will be willing to be embarrassed, to hurt ourselves, if it means being known.

Most of us will be more concerned with that, with being known, than being remembered by anyone special.

Most of us will decide that it's too soon or too late in life to go after what we really want.

Most of us will never actually sit down and think about what we really want.

Most of us will spend more time reading status updates than we spend reading books.

Most of us will take pictures of ourselves instead of actually looking at the world around us.

Most of us will take the one unique and precious life we've been given and spend it being, just ok.

Most of us will make do.

And you will meet most of us and when you do, remember this.

Be the few.

Be the few.

The Atoms On The Edge

Thursday, September 8, 2016

They asked me to point to where it
hurt, and so I pointed at you.

The Diaries Of Foreign Lovers

Friday, July 9, 2010

You are so patriotic to your heart.
It keeps the country together. But it
tears the world apart.

The Sins Of Stationery

Sunday, January 24, 2010

To: You

Every office memo dreamed of being
a love letter. If only it had the words.

The Memento Of Past Promises

Wednesday, February 10, 2010

Hate doesn't work like love.

You have to remind yourself to love.

The Science In The Sky
–
Tuesday, June 21, 2011

I'll hold your hand during the storm,
if you promise to sit back and enjoy it.

The Dark Words You Walk Down At Night
–
Tuesday, September 25, 2012

This is why it hurts the way it hurts.

You have too many words in your head. There are too many
ways to describe the way you feel. You will never have the
luxury of a dull ache.

You must suffer through the intricacy of feeling too much.

The Ghost Farm
–
Wednesday, June 9, 2010

To you, it was just picking flowers.
To them, it was a massacre.

The Beautiful Mess We Could Be

—

Wednesday, April 1, 2009

So may you find in each other what
you came here for. And trust that
this is love because it is (love is trust).
And tangled lives you may lead but
into each other, never apart, till you
cannot distinguish between being and
being together.

The Seconds Can Be Days

—

Monday, February 28, 2011

The moth lives for just one day, and
yet, you will never see it fall to the
ground and curse the futility of its
existence. Nor flowers weep when
winter comes. Nor the moon sigh
when dawn approaches. We are only
ever given just so much. But it is
always, all we need.

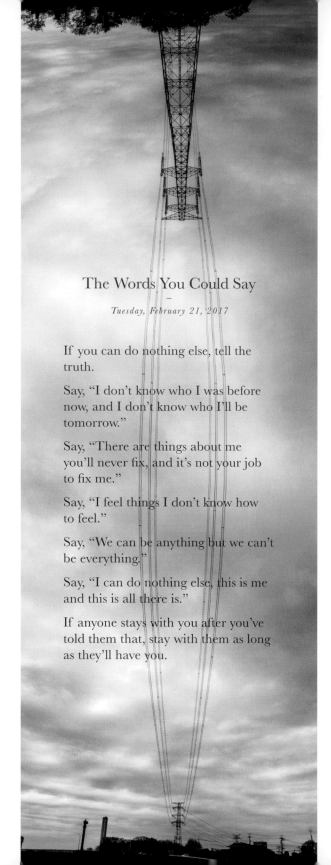

The Words You Could Say
–
Tuesday, February 21, 2017

If you can do nothing else, tell the truth.

Say, "I don't know who I was before now, and I don't know who I'll be tomorrow."

Say, "There are things about me you'll never fix, and it's not your job to fix me."

Say, "I feel things I don't know how to feel."

Say, "We can be anything but we can't be everything."

Say, "I can do nothing else, this is me and this is all there is."

If anyone stays with you after you've told them that, stay with them as long as they'll have you.

The First Time We Met
—
Tuesday, June 30, 2009

It's when you hold eye contact for that second too long or maybe the way you laugh. It sets off a flash and our memories take a picture of who we are at that point when we first know, "This is love."

And we clutch that picture to our hearts because we expect each other to always be the people in that picture. But people change. People aren't pictures. And you can either take a new picture or throw the old one away.

The Small

Monday, August 20, 2007

Joy. Peace. Happiness. All these
things are found in the tiniest of
spaces. You just need to know
where to look.

The Leave Behind

Monday, April 12, 2010

I don't know who you're kissing now.
But I do know who you think about
when you do.

The Bandages Are Made Of Shadows

Tuesday, October 9, 2012

You and I both know, the dark doesn't make the bruises disappear.

It just makes them harder to see.

The Repeat

Wednesday, December 31, 2008

That song you keep playing is nothing
but a photograph you look at with
your ears.

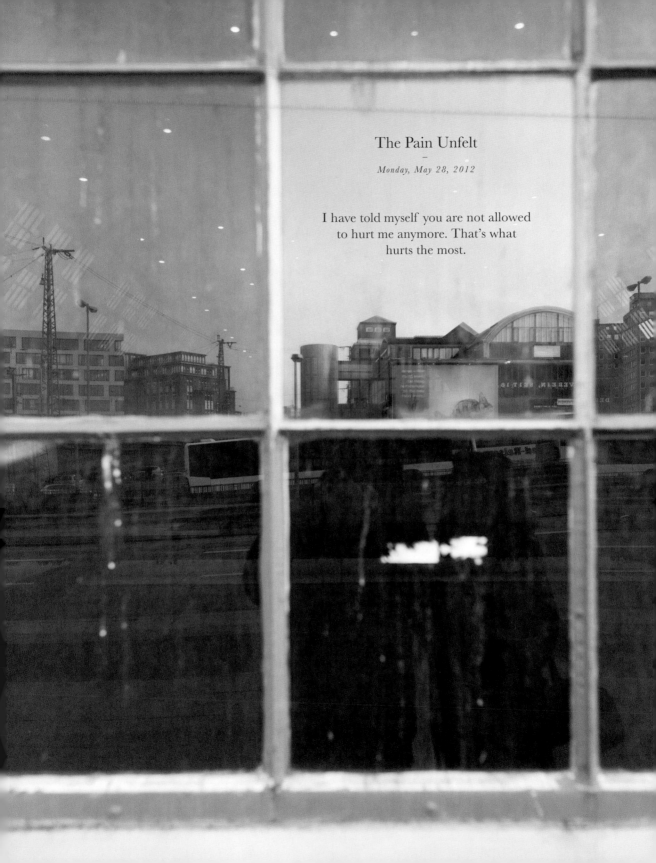

The Pain Unfelt
—
Monday, May 28, 2012

I have told myself you are not allowed
to hurt me anymore. That's what
hurts the most.

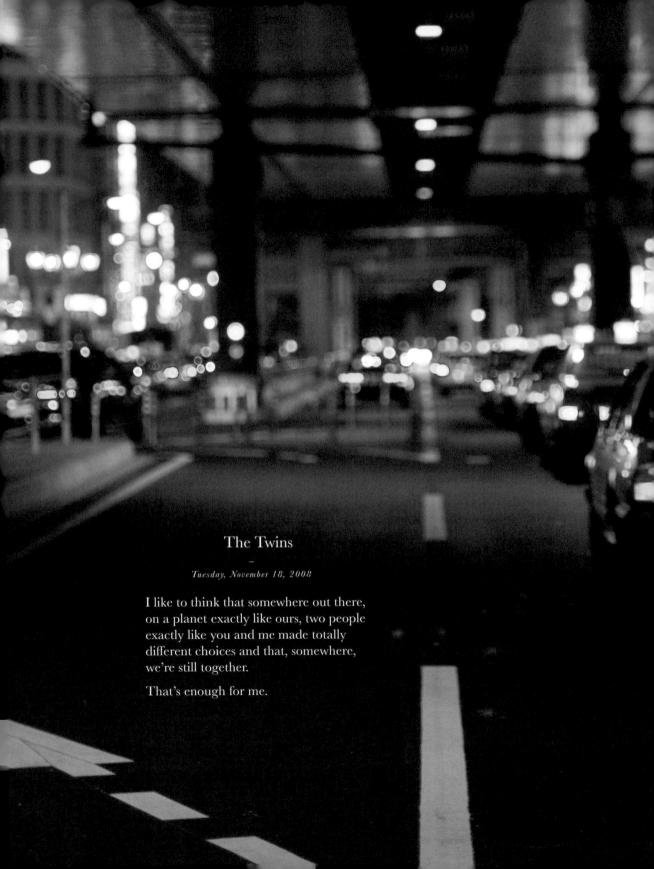

The Twins

—

Tuesday, November 18, 2008

I like to think that somewhere out there, on a planet exactly like ours, two people exactly like you and me made totally different choices and that, somewhere, we're still together.

That's enough for me.

The Crowded Life
—
Thursday, January 24, 2008

You can have the entire world around
you and yet still be completely alone.

The Memory Of Beauty
—
Thursday, December 22, 2011

I hope things are beautiful. And if they're not, then
I hope you remember this moment right now when
they are. Because you've got to hold up each and
every other moment to the moment when things are
beautiful and say,

"Look. I told you. Remember this."

The Distance Between Two Points
—
Friday, October 17, 2008

I don't miss you now. I miss you then.

The Nature Starts To Turn

Friday, April 10, 2009

You're not lost. You are the sky. Your parts move
and now, never rust. You are burning wheels and a
turning world. You are the wind in silver hair.
This is our road. I am a map to you.

The City That Sleeps Where They Fell

Thursday, July 17, 2014

I know you move your fingers when you sleep
because I have felt them move and I know I must do
the same.

And I must wonder how many times we have
unconsciously, in dreams or nightmares, reached for
each other's hands and never even known.

The Vow of Noise

Wednesday, October 7, 2009

I'll understand your silence.
Because sometimes, you'll have to understand mine.

The Chest Cavity

—

Wednesday, November 30, 2011

"It just creates and then fulfils a series of needs."

"That's all it does?"

"Yip."

"So why is it so sensitive? It's not like it's conscious."

"It has a degree of choice but not nearly to the same extent as a certain other machine."

"How do you mean?"

"It creates lists."

"Lists?"

"Yes, lists. It orders the things it wants to do and then does them, in order of what it defines as most important to it."

"It doesn't sound terribly impressive."

"It is the most important machine here. In fact, it creates importance. It decides whether or not you consider the taste of something more important than the effect of it or whether the feeling of a song is more important than how tired your legs are. It decides whether or not it's more important to you to spend time with the ones you love or at work. It decides whether or not it's more important to you to pay your bills or do the things you'd rather be doing."

"Bloody hell."

"You know what the worst part is?"

"What?"

"This isn't the first time I've been called down here to fix it."

"It breaks often?"

"Not often. But it does break. I've seen ones that have broken too often or too much. Held together with bits of tape and string. A great sheet of nothing wrapped around, just so they can hold it together."

"Could that happen to this one?"

"It has the words 'Anything Can And Quite Often Does Happen.' inscribed across the front. What do you think?"

"I think it's insane."

"Correct."

The Princess Is In Another Castle

–

Sunday, July 26, 2009

You cannot go back in time, even if you wish it with every fibre of your being, your heart and soul, even if you think about it every day. Trust me. I know.

The Bleach

–

Friday, August 6, 2010

You are your hair and your eyes and your thoughts. You are what you look at and what you feel and what you do about it. The light from the sun is still a part of the sun. My thoughts of you are as real as any part of you, and that is the only comfort I have.

The Long Hard Road

–

Friday, February 13, 2009

If nothing else, one day you can look someone straight in the eyes and say,

"But I lived through it. And it made me who I am today."

The Audience Of One

–

Monday, July 12, 2010

You're too pretty to be weird and too weird to be pretty.

And you feel strange when people try to talk to you. So get a job, it's safer than art. Maybe people won't point and stare so much. Even if they're only in your head. Especially if they're only in your head.

The Shedding Of Skin

–

Friday, January 9, 2015

If you're not who you used to be, you still have time to become who you could be.

The Light Of All Stars

—

Monday, November 21, 2016

Follow your star.

Because yours is the only star that you can follow.

Everyone else's stars might shine brighter or sit higher in the sky.

But do not get distracted or try to follow stars that aren't your own.

They will lead you places but they will not be the places you're meant to go.

Only your star will take you where you're meant to go.

If your star takes you through a storm, then go through the storm.

If your star takes you into the deepest ocean - then swim.

Because only your star knows where it must go.

And how it must get there.

The night is long and sometimes, your star will be hard to see.

Be patient and close your eyes.

It is always there.

It is waiting for you to follow it.

The Heart Outgrows The Chest

–

Wednesday, February 12, 2014

The further inside you hide the hurt,
the more it hurts inside.

All wounds need air to heal.

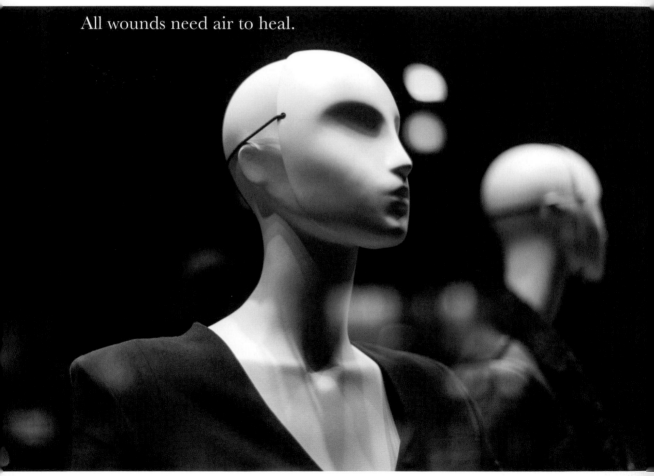

The Soul Of Glass
–
Wednesday, April 28, 2010

That's what you never got. It takes an entire lifetime to write the words, "And they lived happily ever after."

The Metal VS Time
–
Tuesday, July 7, 2009

When you feel like it'll take everything you have and you think that it'll take a lifetime to accomplish, you need to remember that that's exactly what you have.

The Worth
–
Tuesday, August 28, 2007

All your work. All your play. None of it compares to one night spent next to the warm body of someone you love.

You need to learn this sooner rather than later.

The Perfect Apathy
–
Friday, August 7, 2009

You remember and dwell on all the things you've lost and ignore all the things you haven't. Because your scars are like stars. Yet the night stays perfectly black.

The Horrible Thing That Happens

Thursday, May 28, 2015

If you're lucky, the horrible thing that
happens gives you some distance from the
world and it lets you to look at it in a way no
one else does.

If you're lucky, the horrible thing that
happens makes you move closer to everyone
around you because you understand how
bad the horrible thing can be, and you know
there's a chance someone else might have felt
something as horrible as you have.

So you are not careless with others.

You try and make sure the horrible thing
doesn't happen to them.

Because you're the lucky one.

The Colours Run
—
Monday, October 12, 2009

Because you're looking for a date, not love. Because you're more interested in who you go to bed with than who you wake up next to. Because you tick boxes in your head instead of crossing lines in your heart.

The To Not Do List
—
Tuesday, October 20, 2009

There are a million important things to do. But none as important as lying here next to you.

The Dearly Discarded
—
Monday, July 23, 2012

Late at night, when your brain is tired of thinking of everything else, you will find me there. You cannot throw me far enough away.

The Bed Of Clocks
—
Monday, February 22, 2010

I never slept well next to you. But at least I slept.

The Things Which Aren't Love

Tuesday, July 10, 2012

Your salary is not love and your word
is not love. Your clothes are not love
and holding hands is not love. Sex is
not love and a kiss is not love. Long
letters are not love and a text is not
love. Flowers are not love and a box of
chocolates is not love. Sunsets are not
love and photographs are not love. The
stars are not love and a beach under
the moonlight is not love. The smell of
someone else on your pillow is not love
and the feeling of their skin touching
your skin is not love. Heart-shaped
candy is not love and an overseas holiday
is not love. The truth is not love and
winning an argument is not love. Warm
coffee isn't love and cheap cards bought
from stores are not love. Tears are not
love and laughter is not love. A head
on a shoulder is not love and messages
written at the front of books given as
gifts are not love. Apathy is not love and
numbness is not love. A pain in your
chest is not love and clenching your fist is
not love. Rain is not love.

Only you. Only you, are love.

The Things I Would've Said

Tuesday, November 27, 2012

If you're strong enough to take that
blade and draw it across your skin.

If you're strong enough to take those
pills and swallow them when no one's
home.

If you're strong enough to tie that
rope and hang it from the ceiling fan.

If you're strong enough to jump off
that bridge, my friend.

You are strong enough, to live.

The Phantom Limbs

Tuesday, January 31, 2012

And when we speak now, seldom as that is, the old language returns. I wonder if old names make guest appearances in your mind. If you can feel the skin of my neck near yours one more time. Do you reach across the bed for a shape, no longer there. Do you remember it clearly or is it all just memories of memories. Is there still warmth from my fingers tracing the contours of your skin, left somewhere in your body. If you smell the smell of how I used to smell in a crowd, do you think of these things. Is something missing in everyone else's or someone new's voice. Will they never know quite how to laugh or breathe just behind your ear. Do they know what you look like when you want to leave a party, when you've had too much of people. Could they rebuild your body out of clay if they needed to, because they've touched it so many times. Does your back still arch the way it used to when I still kissed you.

Does an old singer sing an old song on an old radio.

Did it sound like this?

The Burst
–
Wednesday, August 22, 2007

Live like nature. Explode slowly, day by day, from the center outwards. You won't notice how brightly you burn or how big you've grown until you look back. And then you will be amazed.

The Series Of Changes
–
Friday, January 18, 2008

You want a new life. But you take the new one you get every morning for granted.

The Escape Plan
–
Friday, January 9, 2009

I'm not the person you left behind anymore. There's no one here to miss.

The Crowd
–
Thursday, August 23, 2007

You think you're the only one who feels small. You think you're the only one who isn't sure what tomorrow might bring. You think you're the only one who's scared the world might eat them.

We suffer together and hold each other tight because when we touch each other, we know:

You are never alone. Ever.

The Bargain
–
Thursday, July 30, 2009

He gave me that night back and this time, I told you the truth. We talked and held each other till the sun came up. And as I went to hell, the devil asked me if it was worth it. I said yes. Yes it was.

The Way Home
—
Thursday, June 19, 2008

Take the long way home.

Live interestingly.

The Age At Which It Happens

—

Thursday, March 22, 2012

One day,
you realise
that there are
some people
you'll never see again.
at least,
not in the same
way.

The Fury Of Water

—

Thursday, January 14, 2010

You can try and hold me back. Build your damn walls, pack sandbags along the edges and yell at the clouds and the rain and the sky to stop.

But I will not relent. I will reach you. Because I am the sea. And I will continue to love you no matter what.

The Person You Meet At The End Is You

—

Tuesday, November 13, 2012

The universe curves, as does the Earth. And as hard as you try and run away from everything you are, you'll find yourself where you left yourself when you come home. Just tired.

Fix yourself before you try to outrun yourself.

The Time It Takes To Fall

—

Wednesday, January 28, 2009

So if all we have is that glance in the window. If all we have is till this train stops. If all we have is till the sun comes up, till your lift picks you up. And If all we have is till the day I die. I'm ok with what we have.

The Fire At Sea

—

Tuesday, July 13, 2010

When the tide goes out for the last time, all the shipwrecks will be waiting for us and the bones of the Earth will shine bright white in the sun.

When the tide goes out for the last time, I'll meet you by the planes that never made it past Bermuda.

When the tide goes out for the last time, I swear, we will have nothing left to lose.

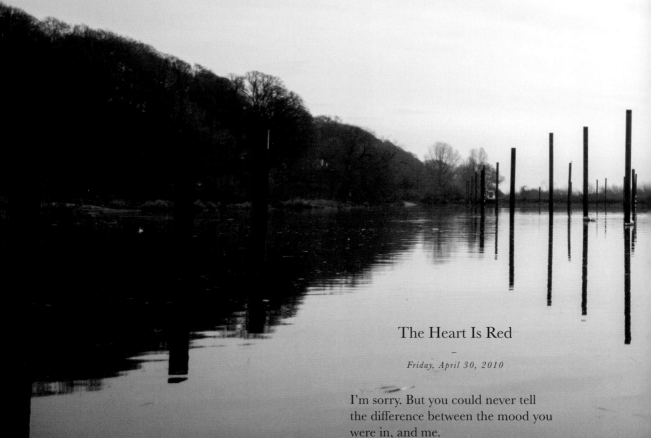

The Agony Of Being Other People

–

Tuesday, January 8, 2013

I keep wondering, how many people do you
need to be, before you can become yourself.

The Nod And The Wink

–

Thursday, September 2, 2010

Time never said,

"Best you enjoy yourself now because
we're going somewhere soon."

But that's what he meant.

The Heart Is Red

–

Friday, April 30, 2010

I'm sorry. But you could never tell
the difference between the mood you
were in, and me.

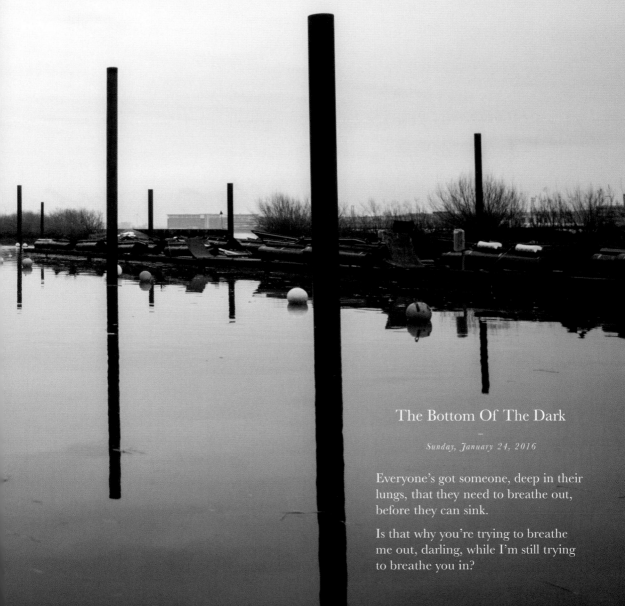

The Guide To Grace When Falling Apart
—
Wednesday, September 30, 2009

Hello. Where are you? Here. Where? Right here. Can you feel that? Yes. That's me. I see. Yes. You feel like me. I am.

The Absence Of Oxygen
—
Monday, October 26, 2009

Forget the air. I'll breathe you instead.

The Bottom Of The Dark
—
Sunday, January 24, 2016

Everyone's got someone, deep in their lungs, that they need to breathe out, before they can sink.

Is that why you're trying to breathe me out, darling, while I'm still trying to breathe you in?

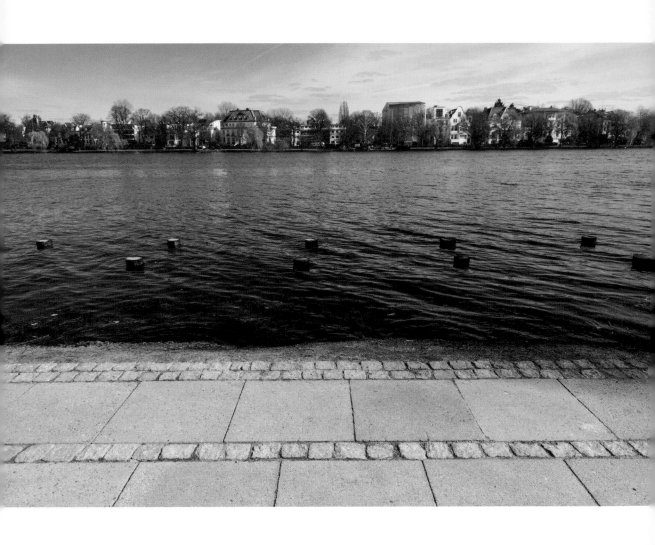

The First Sounds

Monday, April 20, 2015

Before language, there were only sounds, and we had to tell each other everything we could with nothing but the noises we could make with our mouths.

What sound could you have made for, "Look at all these lights in the sky. Isn't it amazing?"

What sound could you have made for, "My chest hurts when you are not here."

What sound could you have made for, "I am hurt, and I am slowly pouring out of me."

What sound would you have made for, "I do not have a name for the feeling I have when I'm with you, but it is a feeling that I never, ever want to end. Please don't go to sleep forever."

The Stones From Other Houses

Monday, March 24, 2014

I wonder if houses miss each other.

I wonder if you can hear them creaking at night, in pain for some other structure they once knew.

A view from a window changed forever by a wrecking ball, a storm or a fire. A place where things used to live.

Why would the universe be so cruel, to build two so close to each other, only to take one away?

And what of the house you build, in the ruins?

The Things I Meant

Tuesday, February 14, 2012

A heart was meant to beat. And air was meant to be breathed, close to your ear. And your skin was meant to remember what mine felt like. And some songs were meant to play on repeat. And the sun was meant to come down. And we were meant to ignore it when it woke up. And days were meant to pass. And nights were meant to follow. And your eyes were meant to cry out whatever pain was left.

And I never meant to hurt you.

But I guess that's what everyone says.

The Strangers In Waiting

Wednesday, February 1, 2017

Everyone talks about
LOVE at first sight
but not once has some
well-meaning soul
turned to me and said

"Do you know
how many
years it
takes
to become
strangers
again?"

The Seat Next To You

Wednesday, June 17, 2009

When I sit near you, my hands suddenly become alien things and I don't know where to put them or what they usually do, like this is the first time I've ever had hands and maybe they go in my pockets and maybe they don't.

The World Of Your Own

Tuesday, October 21, 2014

How sad it is that you're somewhere else, when you're here.

The Last Fall

Friday, December 2, 2016

Perhaps you only find out at the end of your life that happy is as good as it gets.

And there's nothing that lasts that can be anything more.

Maybe looking for more is like going to the edge of a cliff, and walking into the beautiful view.

The Laughter Stopped You From Crying

Monday, February 15, 2010

If you can pretend as hard as I'm pretending, this can be the first time we've ever met. Not the last.

The Beauty Of Errors

Wednesday, November 11, 2009

I made a lot of mistakes before I got to you (each one honest and none that I regret). The same way a tree bends in the wind and twists and turns, before it can touch the sky.

The Immortal Sadness

Monday, August 24, 2015

I know you have a great sadness. I
have had a great sadness too and I
want you to know: I am alive and
one day, you will say this same thing
to someone else.

The Tiny Iceberg
—
Friday, July 16, 2010

The little things you
forget, kill me.

The View From The Bottom

–

Monday, October 26, 2015

It's not that bad. If you want to be sad, come and write sad songs with me. Or we can sit and watch movies. You won't have to worry about bringing me down - I am already down. I will watch the blackness swallow you and you can watch the blackness swallow me too.

The Moment My Skin Brushed Against Yours

–

Monday, January 26, 2009

But really, all we want, and I speak for the entire human race here, is contact. Someone to let us know that we aren't alone. That the world isn't a dream and you and I really are happening at the same time, even if it's not in the same place. That this is real. You're really there. I'm really here. We're real.

This is real.

The Sound At The Back Of Your Throat

–

Friday, January 23, 2009

Our language is dead. No more heavy consonants and long vowels with soft meanings. No more names only you and I know.

Because no one speaks *Us* anymore.

The Best Way To Run Into Traffic

–

Tuesday, February 10, 2009

It does not count if you believe in yourself when it's easy to believe in yourself. It does not count if you believe the world can be a better place when the future looks bright. It does not count if you think you're going to make it when the finish line is right in front of you.

It counts when it's hard to believe in yourself, when it looks like the world's going to end and you've still got a long way to go.

That's when it counts. That's when it matters the most.

The AWOL Hearts

–

Friday, November 6, 2009

Let's play hopscotch in malls. Let's drive fast with the top down. Let's turn up the music as loud as it'll go. Let's put a couch on an island in the middle of the freeway and wave at everyone on their way to work. Let's hug strangers in parking lots. Let's hand out secret messages at traffic lights. Let's make lists of all the things that make us smile and tick them off, one at a time. The world will carry on without you and me when we're gone. Let it carry on without us, today.

The Molten Core

–

Monday, September 20, 2010

This world is hard. It has sharp edges and points that cut. It'll make you choose between love, money and sleep. Choose love each time and sleep when you can, money - only when you must.

Because this world is hard. And at times, it is too hard, for me.

The Contradictions Make Me

–

Tuesday, November 4, 2014

Poetry is a way to take pictures of
things you can't take pictures of.

Pictures are a way to say things you
can't say.

This is a way for me to do things that
I can't do.

The Shade

—

Tuesday, September 30, 2008

You were always my dark cloud
that let me stare at the sun.

The Glass Sphere

—

Tuesday, September 15, 2015

Even if you are made of night, try
to be made of more starlight than
darkness.

The Parts We Keep

—

Wednesday, January 11, 2017

Don't let them kill the parts of you that they don't like.

Keep all of you and never be afraid to be everything you are.

The Inkblot Test

—

Monday, August 17, 2015

Tell me what you see, when I fold my
heart in paper, crush it, and open the
pages again.

The Picture We Make

—

Monday, June 1, 2009

Fine. Maybe I'm the puzzle.

But you're still the pieces.

The Efficiency And Perfection Of The Lost

—

Monday, November 5, 2012

Yet you still value the things you've lost the most. Because the things you've lost are still perfect in your head. They never rusted. They never broke. They are made of the memories you once had, which only grow rosier and brighter, day by day. They are made of the dreams of how wonderful things could have been and must never suffer the indignity of actually still existing. Of being real. Of having flaws. Of breaking and deteriorating.

Only the things you no longer have will always be perfect.

The Stories You Tell

—

Tuesday, January 8, 2008

Life is not a story. No matter how much you'd like it to be.

Life is life. It can end, begin and become whatever you want it to be.

Nothing is written down.

The Sky Is A Distraction

—

Monday, September 7, 2009

I can look anywhere in the world but at you. And it hurts to look anywhere in the world but at you.

The World Would Be Easier

Monday, October 22, 2012

The world would be easier if the homeless
were all just lazy and all they needed to do
was just get a fucking job.

The world would be easier if evil were
a real thing, instead of just confusion,
misunderstanding, miscommunication and
misplaced desire.

The world would be easier if you could
just be happy for what you had, while you
had it. If you could eat memories like
flowers to keep your heart alive.

The world would be easier if comfort
didn't rest on the backs of the broken, if
your swimming pool was dug by soft hands
that never worked a day in their life.

The world would be easier if we all just
got rich and famous and we were all each
other's #1 fan.

The world would be easier if it were an
automatic.

The world would be easier.

But it isn't.

The world is hard because it requires real
human effort to make it turn.

The world is hard because you may wake
up today but not tomorrow. And yet no
one will accept "fear of death and a futile
existence" as a reasonable excuse to miss
work.

The world is hard because you will have to
fight for the things you love or worse, fight
the things you love.

The world is hard because the things you
love will kill you.

The world is hard because it was made
that way by thousands upon thousands of
hard men and no one wants to admit we
have no idea why we're doing the things
we're doing anymore.

The world is hard because it's hard to
forgive and even harder to forget.

The world is hard and you should just
give up, right now. Just lay down and die.
Nothing will ever be easier.

But, you don't.

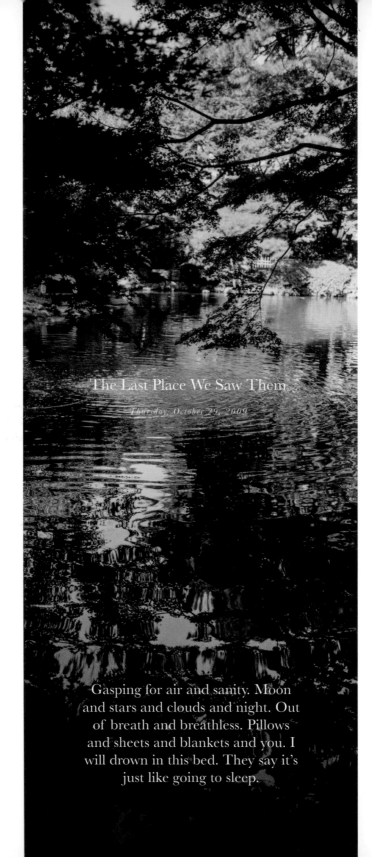

The Last Place We Saw Them

Thursday, October 29, 2009

Gasping for air and sanity. Moon
and stars and clouds and night. Out
of breath and breathless. Pillows
and sheets and blankets and you. I
will drown in this bed. They say it's
just like going to sleep.

The Universe Will Take You

Thursday, January 26, 2012

They might not like you at school.

And they might not like you at work.

And they might not like you in a park.

And they might not like you on the moon.

And they might not like you in summer.

When you say they remind you of winter.

But this universe, will always love you.

This universe, will take you.

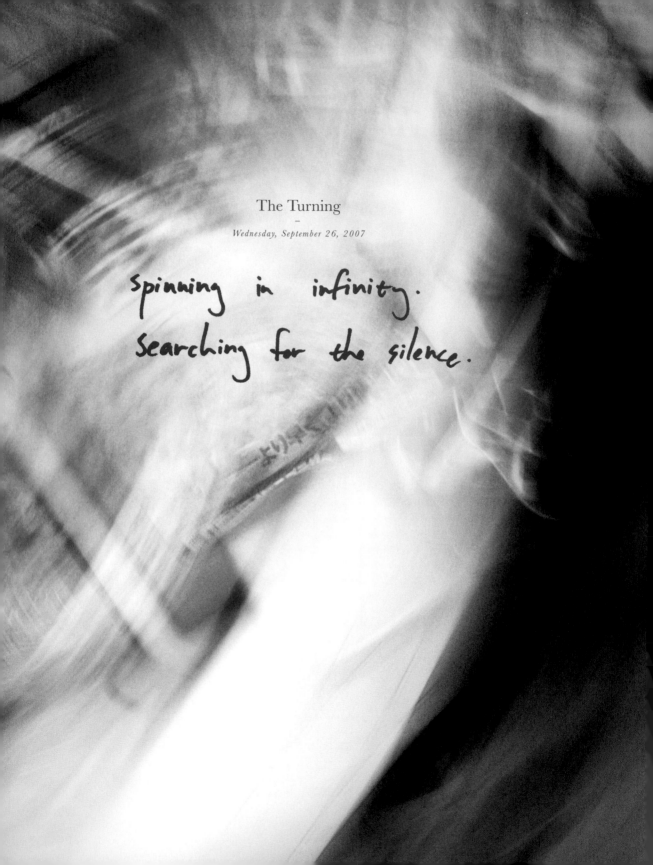

The Turning

–

Wednesday, September 26, 2007

Spinning in infinity.
Searching for the silence.

The State Of The Artist

—

Tuesday, January 10, 2012

You, as an artist, have the greatest responsibility of all.

You are charged with trying to make people feel, in a world that tells them not to.

You are tasked with speaking soft words, painting, playing, filming, writing moments of such magnitude and beauty that people rediscover their hearts one more (last) time.

You are here to give meaning to the few decades we spend here.

That is the reason you were sent to Earth.

The Art Of Breathing

—

Tuesday, November 22, 2011

And in the beginning, my lungs had too much air in them, whenever you were near, like I could never breathe out enough.

And in the end, my throat closed, whenever you were far, like I could never breathe in again.

The Camera Is A Bag For Memories
—
Monday, January 7, 2013

And when someone takes my picture and they tell me to smile, I still think of you.

The Nature Of Being

–

Thursday, February 21, 2008

Unfold before the world, let it in,
let yourself out.

The Intrusion

–

Monday, February 4, 2008

You are well within your rights to stand
up, interrupt everyone around you and say,
"This is not who I am. This is not what I
want. I'm sorry, but you've mistaken me
for somebody else."

The Campaign For Shorter Days

–

Thursday, February 19, 2009

When we get to the end of this, you're
going to need to remind me whose turn it
is to leave.

The Impossibility Of A Normal Day

–

Monday, January 19, 2015

I think there are two things everyone has, the one is The Great Sadness and the other is How
Weird I Really Am. I think everyone has them but only some of us are brave enough to talk
about them.

I don't know if I'm brave but I do know that sometimes I'm sad and sometimes, I worry about
how weird I really am and if you do too, that's ok.

We'll both be ok. We'll both be weird and sad and ok together.

The Stupid Things I Need To Hear

Monday, February 22, 2016

Sometimes people who you like, won't like you.

That's ok.

Sometimes, everyone around you will talk about all the incredibly cool things they're busy doing and you will have very little to talk about yourself.

That's ok.

Sometimes, you will wake up and you'll just be sore for no real reason.

That's ok.

Sometimes, you won't know what to do and people will say, "I'd kill to have your problems!" and that won't magically and suddenly stop them from being problems.

That's ok.

Sometimes, I'm saying it to you because I hope that one day, you'll be able to say it to me.

"That's ok."

The Remaining You

—

Monday, September 26, 2016

Someone knows the you that goes to bed early because you can't talk.

Or the you that doesn't stop talking when they're excited.

I'm sure someone knows the you that stays up late because your head is too busy, no matter what you tell it to settle down.

There must be many, who know the you that you wish other people thought you were. And more that know the you that other people actually think you are.

And perhaps a few know you, at least, know the you that you think you are.

But only I know the you that's left, when the rest of you has gone away.

The Wind Blew The Light Away

—

Wednesday, November 20, 2013

The world didn't end in fire. It just blew away in the rain.
And who can say anything at all.

Maybe, if you are anywhere at all, you can say to someone
in Italy, Indiana or the Philippines, "Don't worry, we are on
our way."

I will say, "Just for now, it's ok to believe in ghosts."

The Hands You Gave Me

—

Friday, February 14, 2014

Everything started when my hands touched yours.

And I've done such sad things with my hands since
then and I know you have too.

And I know we'll find light in smaller hands than
ours one day soon.

And I hope our hands grow old in each others.

If not, then why have hands, at all.

The Last Meal Request

–

Thursday, November 24, 2011

You don't get to yell at me for
being dead, if you're the one
that killed me.

The Circle, Triangle, Square

–

Wednesday, August 19, 2009

If you've got the time, we can play a game. It's easy. We just see if I'm the same shape as the space you have inside you. If everything fits, we both win. If it doesn't, don't force it. That's how you get splinters in your heart.

The Next Stop

–

Thursday, August 12, 2010

Only because it's still so raw and real. Soon I'll just be a series of images that sometimes flash through your mind, when you least expect it. And after that, only a few will stay. Then, one: A memory of a memory.

The Invisible Warning Labels

Tuesday, March 10, 2009

You'd think it would be easy for them
to mark with red the cigarette that
killed you so that you wouldn't smoke it,
the drink that does you in with a label
cautioning you not to, the kiss that ends
the world with flashing lights that spell
out the words,

"Stay Away."

The Slight Pinch

Tuesday, August 11, 2009

You and I could collide, like atoms in
some scientist's wet dream. We could
start a new universe together. We could
mix like a disease. And if we do, I hope
we never get better.

The First Sign Is Taking Strange Pictures

—

Wednesday, July 15, 2009

I have pretended to go mad in order to tell you the things I need to.
I call it art. Because art is the word we give to our feelings made public.
And art doesn't worry anyone.

The Invisible Postal Service

—

Wednesday, November 16, 2011

I keep thinking you already know. I keep
thinking I've sent you letters that were
only ever written in my mind.

The City Rises And Falls

—

Friday, May 14, 2010

You were a dream. Then a reality.
Now a memory.

The Failure Of Prayer

—

Wednesday, February 17, 2016

I tried to tell you how much you mean to me.

How every part of you is made of the dark side of light.

How seconds hit like glass hammers.

How every millimetre of your skin softly sings a song only it knows.

I tried to tell you how much you mean to me.

How a billion black oceans float between the things you say.

How shadows chase shadows.

How low the birds fly when I blink.

I tried to tell you how much you mean to me.

How this house becomes church light in autumn.

How we can be, and be, and be, and be again.

How a porcelain heart can beat so hard it breaks itself.

I tried to tell you how much you mean to me.

But all that came out was poetry.

The Way Forward

Thursday, May 26, 2016

You should never pass up the chance to break your heart in new and interesting ways.

The Reason The Willow Weeps

—

Monday, August 31, 2009

It weeps for you late at night, when sleep does not come easily. It weeps for the one you miss. It weeps for the dreams on the tips of your fingers. It weeps for appointments missed and it weeps for the tears in your pillow. It weeps for the silence and it weeps for the noise. It weeps for formal letters where once, language was spoken as close to your ear as possible. It weeps for betrayal, intended or not. It weeps for the friends you once were. It weeps for the colours faded. It weeps for sunrise. It weeps for a death in the family and it weeps when a baby is born. It weeps for the last time you touched. It weeps for words that can never be taken back. It weeps so hard and so much and so often. So you don't have to. So you can carry on. It weeps for you. When you have run out of weeping.

The Fragments Belong Together

Friday, August 28, 2009

Things just break sometimes. Maybe we should blame that third person we became, that personality we shared together. Maybe it's their fault because you're a good person and I think I'm a good person too. We just weren't made for this.

The Child With The Invisible Head

Monday, September 10, 2012

And what still shocks me, is how often the thing that hurts you, looks like the thing that helps you.

The Hate Feeds The Hate

Friday, January 13, 2012

You say there is an 'us' and a 'them' and we must fight. I say there is only an us. And we must love.

The Ground Will Give Way

Monday, November 16, 2009

The bad news is, your choices and intentions, some people and places, those nights spent awake and all you've done, can lead you to the bottom of the pit.

The good news is, this wouldn't be the first time someone's crawled, tooth and nail, out of hell.

The Place I'm In

Thursday, April 16, 2009

You cannot kill me here. Bring your soldiers,
your death, your disease, your collapsed
economy because it doesn't matter, I have
nothing left to lose and you cannot kill me
here. Bring the tears of orphans and the wails
of a mother's loss, bring your God damn air
force and Jesus on a cross, bring your hate and
bitterness and long working hours, bring your
empty wallets and love long since gone but
you cannot kill me here. Bring your sneers,
your snide remarks and friendships never felt,
your letters never sent, your kisses never kissed,
cigarettes smoked to the bone and cancer
killing fears but you cannot kill me here. For I
may fall and I may fail but I will stand again
each time and you will find no satisfaction.
Because you cannot kill me here.

The Wedding
Thursday, September 13, 2007

Sometimes the sun shines and it still
rains. The weather changes all the time.
You can too.

The Sheer Arrogance Of Loneliness
Saturday, January 3, 2009

Making love was never about you and me in a
bed. We made love whenever we held hands.

The Last Part Of This Sentence Is Still Yours
Friday, June 13, 2014

You still take things from me in the most beautiful way.

You are still the only way I can sleep, when I wake up to tell you, I cannot sleep.

You still make sense in a way that only birds know when they leave winter.

The New Species
Wednesday, October 28, 2009

I want to weave you into me. Stick your thorns in and grow.
Bleed sap and feel this shining light. Grow strange leaves. Bear
this fruit. Share this soil. Bury ourselves. Reach for the sun.
Strip this bark. Carve a name and a heart into me. Please.

The Flickering Light

—

Wednesday, July 8, 2015

"I had trouble sleeping" is just another way of saying you spent the night fighting ghosts in the dark.

The Jacket Weather

Monday, April 14, 2014

Loneliness is a kind of winter. And
you drag me, kicking and screaming,
into some kind of bright summer.

The Descent Into Light

Monday, June 30, 2014

If you're not afraid, there is no end,
only an imminent bliss. So burn like
love and love like fire.

The Stars Whisper To Planes (Sometimes Trains)

Wednesday, February 4, 2009

Services were held for us at major international airports and the same song was
played each time. I hope that somewhere, somehow, you heard it.

The Stranger In Waiting

Sunday, November 1, 2009

I'm sure you've met them. They say they'll
put you back together while they're tearing
everything apart. And they use the type of lips
you can taste for years.

The Sound A Passing Heart Makes

Sunday, May 17, 2009

You will hear it and no one else will, like
your soul wears headphones and only it
can hear the music.

The Wind Stops Screaming

Thursday, May 21, 2009

No storm is so bad that you can't learn
something from it. You can grow in a
storm. You can thrive. Rain cleans the air.

The Storm Before The Calm

Thursday, February 2, 2012

You're still here but I am still the sea.
And as peaceful as I seem, please
don't ever turn your back on me.

The Place Everyone Worked

Tuesday, April 13, 2010

If you don't think I'm important, you're a no one, not a someone.
Because everyone is important to someone.

The Trees That Decided Not To Die

Thursday, March 25, 2010

As I put down my pen, I know someone, somewhere is picking up theirs.

I know that someone, somewhere is playing a guitar for the first time.

I know that someone, somewhere is dipping a paintbrush and marking a field of white.

I know that someone, somewhere is singing a song that's never been sung.

Perhaps someone, somewhere will create something so beautiful and moving, it will change the world.

Perhaps that somewhere is here.

Perhaps that someone, is you.

The Ticket Is Valid

—

Monday, November 9, 2009

And maybe I'll sleep at the station because there's nothing to go
home to but an empty fridge and some stale mayonnaise.

And maybe I'll make friends with the guys sleeping under
cardboard boxes and newspapers and we'll discuss what it means to
love and to live.

And maybe I'll wander the city, one lost particle in a dust storm of
Mondays, late nights and reports due yesterday.

And maybe I'll get on a plane or a ship and get lost in places I've
never been lost in before.

And maybe I'll keep my phone on me in case you call.

And tell me there's something to come home to.

The Wet Hair And Eyes

You are a drop of perfect
in an imperfect world.

And all I need, is a taste.

The Briefest Respite

–

Tuesday, April 22, 2014

If all you do is make something
beautiful for someone else, even if it's
only for a moment, with a single word
or small action, you have done a great
service.

Because life can be ugly and
frustrating and for so many, it is.

The Reminders In The Sky

You are the distance
between the way things
are and the way I want
them to be.

182

The Garbage I Became

Monday, November 7, 2011

Now the TV's on at 3am and you're sleeping on the couch, because you can.

Now the plate is where you left it, no one else is going to move it for you.

Now the politics of blankets are gone.

Now the people on the radio sound so far away.

Now you've got no plans when you wake up, just keep on keeping on.

Now the morning fades to light, to twilight, to night.

Now you rinse and repeat.

Now you remove the sleeve and remove the film.

Now you remove the sleeve and pierce the film several times.

Now dinner takes exactly 2:30 minutes.

Now the Earth hurtles through the universe around a giant ball of fire.

Now none of your acquaintances know they're really your only friends.

Now none of your friends know they're just acquaintances.

Now you've got to get used to being alone, like when you're born, like when you die.

Now you're free.

Now you can do whatever you want.

You just have to do it alone.

The Packaging Of People

—

Monday, March 7, 2011

"But this is just another box."
"No it's not, it's the box we put you in if you
say, 'Don't put me in a box.'"

The Possibility Of Clouds And Thunder Showers

—

Friday, July 17, 2009

Oh, how I wish you wouldn't worry so. There's hope in every
breath. But when fear infects the bones, I'm told, the heart is
always next.

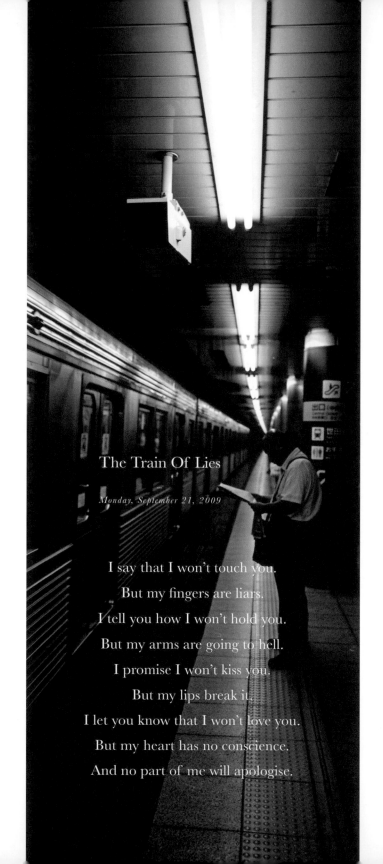

The Train Of Lies

Monday, September 21, 2009

I say that I won't touch you.

But my fingers are liars.

I tell you how I won't hold you.

But my arms are going to hell.

I promise I won't kiss you.

But my lips break it.

I let you know that I won't love you.

But my heart has no conscience.

And no part of me will apologise.

The Way You Lie Here

–

Monday, August 3, 2009

Don't you dare tell me nothing matters. Everything
matters. Every fucking drop of rain, every ray of
sunlight, every wisp of cloud matters and they matter
because I can see them and if I can see them then they
can see me and I know that there's an entire world that
cares out there, hiding behind a world that doesn't,
afraid to show who it really is and with or without you,
I will drag that world out of the dirt and the blood and
the muck until we live in it. Until we all live in it.

The Scratches That Made Me
–
Tuesday, September 22, 2009

You buy things and you keep them clean. You
take care of them. Keep them in a special
pocket. Away from keys and coins. Away from
other things that should be kept clean and taken
care of as well. Then they get scratched. And
scratched again. And again. And again. And
again. Soon, you don't care about them anymore.
You don't keep them in a special pocket. You
throw them in the bag with everything else.
They've surpassed their form and become
nothing but function. People are like that. You
meet them and keep them clean. In a special
pocket. And then you start to scratch them. Not
on purpose. Sometimes you just drop them by
accident or forget which pocket they're in. But
after the first scratch, it's all downhill from there.
You see past their form. They become function.
They are a purpose. Only their essence remains.

The Missing Machine

–

Monday, October 31, 2011

There's a folder of pictures I can't open.

There's so many songs that don't sound the same.

There's a number I can't dial and a message I can't send.

There's a restaurant I can't eat at, not with any friends.

There's words and names I can only say in my head.

There's a pair of eyes that belong to you, that I can never look into again.

The Inscription

—

Thursday, September 3, 2009

This is how I live. This is how I live. This is how I live.

I mumble things under my breath, three times so I'll remember.

This is where I live. This is where I live. This is where I live.

Inside the sun, beneath the burning trees.

This is how I love. This is how I love. This is how I love.

Touching you, in case there comes a time I can't.

This is where I love. This is where I love. This is where I love.

In the heart of things, on the tips of waves.

This is how I die. This is how I die. This is how I die.

Too fast, not long enough.

This is where I die. This is where I die. This is where I die.

Here.

The Reactions

–

Thursday, August 7, 2008

If you jump, the universe will catch you.

If you open your arms, the world will do the same.

The City Has A Lullaby
—
Monday, August 22, 2011

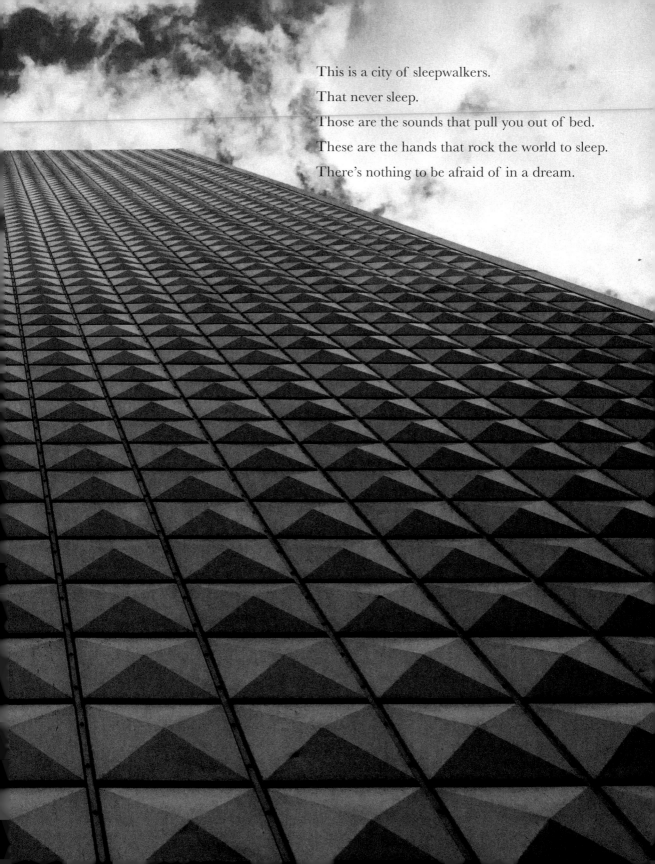

This is a city of sleepwalkers.

That never sleep.

Those are the sounds that pull you out of bed.

These are the hands that rock the world to sleep.

There's nothing to be afraid of in a dream.

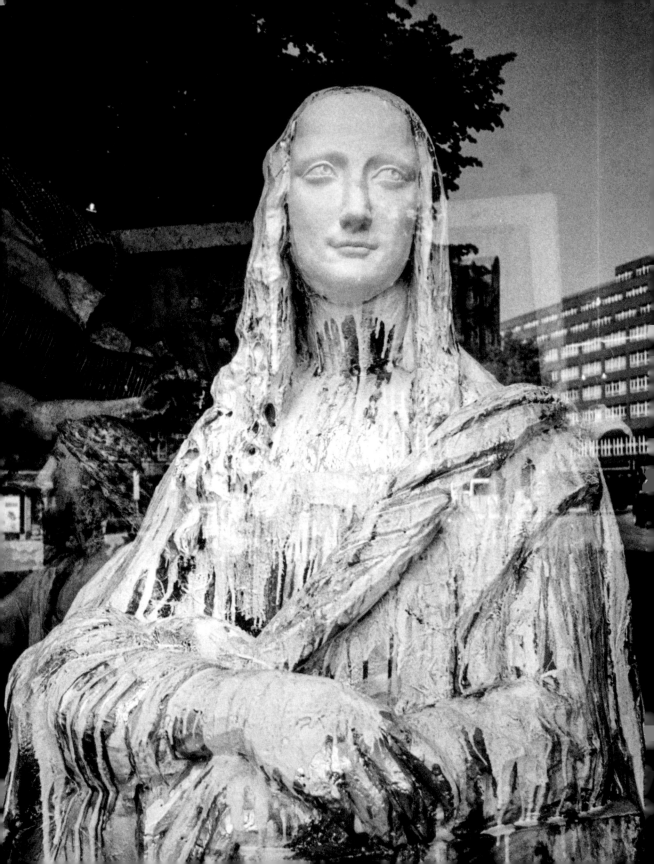

The Winter Child

—

Friday, October 26, 2012

In bright white snow, when everything sleeps.

And hope has left you lonely.

When all you ever remember about summer is how it ended.

I send hope back to you, wherever you are.

I hope you remember all the people you still have time to be.

I hope the little things in your life inspire you to do big things with it.

I hope you remember that summer comes every year and that the sun, is
still sweet.

I hope you learn to hope again.

I, still, hope.

I promised a lot.

But never that I wouldn't get back
up after you knocked me down.

Never that my broken remains
wouldn't catch fire.

Never that I wouldn't burn
through the ice and snow one more
time.

And you can slam your glaciers
into me, so slowly, and even though
they hurt, I will not go numb from
the cold, I will not pass out from
the pain, I will look up at you and
the world and whisper through
bloody teeth,

"More..."

The Midnight That Lasted Forever

Wednesday, August 11, 2010

Somewhere, there is a beach that time cannot reach. Where everyone and everything has always been and never was. And perhaps, you are there waiting for me.

In that place, time cannot touch.

The Solitary Figure

Wednesday, November 26, 2008

You are defined by the way in
which you treat the people you
love. And, the people you hate.

The Space Between Seconds

Monday, September 22, 2008

It's not your watch I care about.
It's the time you keep.

The Place I Do Not Rest

Thursday, February 6, 2014

Dress your heart and mind in what you love, fill your eyes with wonder and
chase the things that inspire and delight you.

For in you, is where I still live.

The Water Flows Uphill

Monday, July 6, 2009

The heart is a muscle like any other
and the best exercise you can do for it is
called picking yourself up off the floor.

The Importance Of Correctly Numbering Things

—

Wednesday, October 24, 2012

There are more grains of sand in the soles of your shoes than you will be given winters to dream or summers to make those dreams real.

And there are more stars in the sky than there are grains of sand on Earth.

We live in a universe so big that a dying star, in the greater scheme of things, is as significant as spilled milk or an unkissed kiss. In an infinite amount of time, everything that can be forgotten, will be forgotten.

In infinity, spilled milk and dying stars matter the same.

And if you're just someone brushing your teeth late at night or you're a planet breathing your last breath as you disappear into a black hole, everything you do matters just the same. Every breath you take is as important or unimportant as the sun in the sky or the moon in the night.

Scratching your ear, is a kind of miracle, depending on how you look at it.

The Person You Are Is Better Than The Ghost You Were

–

Tuesday, April 20, 2010

If the type of person you wish existed doesn't, then that is who you must become.

The Excuse For Your Company

–

Sunday, February 22, 2009

I was wondering if you had a second. To talk about anything at all.

The Air In Space

–

Tuesday, April 20, 2010

If you ever forget how to breathe, I can remind you.

The Stuff That Matters

–

Wednesday, October 15, 2008

I want to fight over little things with you.

The Glaring White Beyond Heartbreak

–

Monday, February 3, 2014

Beyond heartbreak, lies soulbreak, which is when you cannot spend time with someone, not because you and them have chosen to part ways, but because they no longer inhabit the Earth.

The Fading Grey
–
Sunday, April 19, 2009

It's easy. You just love me with all your heart and soul till the end of time.

The Paint Hides The Brick
–
Monday, June 21, 2010

You took all my words when all I wanted to do was say them.

The Light Of Future Memories
–
Monday, April 2, 2012

You make me nostalgic for a love that hasn't even happened yet.

The Rose Tinted Glasses
–
Monday, July 25, 2011

You reach a certain age where you learn how to walk through a crowded party without stepping on anyone's feet. You reach a certain age where you learn how to wear the skin you've been given. You reach a certain age where you can look at your relationships to other people completely objectively. Or at least, that's what I've been told.

The Glitter Phoenix Burns Again
—
Thursday, August 27, 2009

I won't compose prose every morning you open your eyes next to me (I won't compare you to a summer's day).

I won't kiss the tears from your cheeks whenever you cry.

I won't remember every appointment.

I won't keep the sheen on my armour.

I won't know what to say sometimes.

I won't get your order right.

I'll be late.

I'll fuck up.

But I'll write something for you when you least expect it (in summer or winter).

But I'll hold you as tight as I can whenever I can.

But I'll burst through the door as soon as I remember.

But I'll polish it until it shines again.

But I'll say something anyway.

But I'll go back and make it right.

But I'll get there.

But I'll try.

The World Is Better Backwards

–

Tuesday, July 27, 2010

I never saw you again. You slammed the door as you came in. We yelled at each other about something that just shouldn't fucking matter but for some reason, it does. It happened. We spoke softly. We were in bed. I told you,

"I love you."

You said the same. We went to movies and parties and friends' and ate and drank and made love.

It all ended with my eyes meeting yours for the first time and the sudden, extreme feeling of expectation.

And now, how can I miss what has never existed.

The Layers Unseen

–

Thursday, June 4, 2009

There is magic even here, in gridlock, in loneliness, in too much work, in
late nights gone on too long, in shopping trolleys with broken wheels, in
boredom, in tax returns, the same magic that made a man write about
a princess that slept until she was kissed, long golden hair draped over a
balcony and fingers pricked with needles. There is magic even here, in
potholes along back-country roads, in not having the right change (you
pat your pockets), arriving late and missing the last train home, the same
magic that caused a woman in France to think that God spoke to her, that
made another sit down at the front of a bus and refuse to move, that led
a man to think that maybe the world wasn't flat and the moon could be
walked upon by human feet. There is magic. Even here. In office cubicles.

The Secrets Hidden In Stone

—

Wednesday, May 6, 2015

There are people doing great things that they don't know are great yet.

They sit in their bedrooms, not knowing they are writing the most beautiful song you will ever hear. They go to their jobs, hiding great novels somewhere in the depths of their computers. They paint, not knowing how important their picture will be.

They do all this with no promise of any reward or any recognition, and so there are truly great, secret things, everywhere. Waiting to explode.

It is the most beautiful thing in the world.

The Cosmic Joke

—

Tuesday, September 27, 2011

And yet, of all these things, we feel sadness the most. We are never buoyed upon an ocean of apathy. We are never crushed by complacency. We are never moved by the okayness of the world.

Sadness and pain, to help us flee danger and hurt. To help us get away when we're bleeding. You have a body and it screams, "Something stirs like broken glass in my chest, leave this place, before I die."

An animal part of us, still here after all these years, breaks our hearts.

The World Is Not As Dark As It Seems

—

Friday, August 15, 2014

If you ever wake up, and think that no one needs you, I need you.

If you ever wake up, and think that there's no love, I will always love you.

If you ever wake up, and can't find your purpose, I will hold a candle and help you find it.

If you ever wake up, and don't know who or why you are, I can tell you.

If you ever wake up, and don't know why you bothered, I will remind you.

Please remember me, and let me give you reasons.

The Place The Light Strikes Red

—

Tuesday, November 8, 2016

I write down every reason to be afraid on your wrists,
and below my eyelids, where the light strikes red.

You might get addicted to someone.

You might get addicted to being alone.

You might get your heart broken.

You might have to mend it yourself.

You might die.

You might even, live.

The Moths Arrive In Black And White

Friday, January 15, 2010

The bad news is, people are crueller, meaner and more evil than you've ever imagined.

The good news is, people are kinder, gentler and more loving than you've ever dreamed.

The Armistice

Sunday, October 5, 2008

We wanted a war but we called it peace. And we bombed each other's cities till nothing was left. Now you've left me alone to take care of the wounded. The least you could've done was help me bury the dead.

The Strangers Were Lovers

Monday, December 7, 2009

You look at me, now, like this and think, "This is who they were all along."

But this is just who I am to other people. And you became other people.

The Gap In Happiness

Wednesday, March 25, 2009

You are so full of the things that you don't have that you don't have space for the things you do.

The Way Saturn Turns

—

Wednesday, May 27, 2009

All I can do, if I feel this way, is trust
that somewhere in the universe,
there's a you that feels the same.

The Fellow Passenger On A Crashing Train

Monday, March 31, 2014

Even though I've just met you, I believe we will be friends.

First, I will tell you something about me, then you can tell me something about you, as that, I believe, is how friendship works.

Here is something I believe: I believe that we don't know how people work when we're young and maybe that's why we're so reckless with each other when we're young.

I think people think that people come and go, in and out of life and I think that school teaches them that, that life changes in big annual movements, that one year you're this and the next, you're that. But life blends into itself as you get older and you realise, you will watch a few, if not many, of your friends get old.

You will watch them lose their minds and their hair. You will watch them get sick and get better. You will watch them succeed and fail. You will watch them get married, get divorced, get pregnant and yes, eventually, you will watch them die. Or they will watch you die.

So this is what I believe friendship means. And I'm sorry to have to put such a heavy burden on you. But you have put the same burden on me.

Now you can tell me something you believe, as it is your turn, and this is how friendship works.

The Correct And Proper Way To Feel

Wednesday, January 18, 2012

"Is this how I'm supposed to feel now?"

"I don't know, I'll check the manual."

"And?"

"It says that you're feeling the right way."

"What way is that?"

"It says that there is no right way to feel but, right now, after something like this happens, you do need to feel however you're feeling and that feeling this way, however you're feeling, is healthy."

"That doesn't sound very scientific."

"It has nothing to do with science."

"Does it say anything else?"

"It says you'll break something if you beat yourself up for the way you feel and that you won't be able to feel differently until you've finished feeling this feeling."

"Ok. How long will that take?"

"I don't know. How do you feel?"

The Backyard Hymns

—

Sunday, May 3, 2009

You might not always like me, the things I do
or the way I do them. But these are my things,
this is the way I do them and I am me.

The Translation Service

–

Friday, May 8, 2009

And when I asked you how you'd been I meant I missed you more than I've ever missed anything before.

This is my skin.
 It keeps out rain
 and words I'd rather not hear
 like "I'm tired
 or "I'm fine"
 or
 "We need to talk."
This is my skin
 and it's thick.
This is not your skin.
 Yet
 you are still under it.

The Skin I'm In

—

Thursday, January 13, 2011

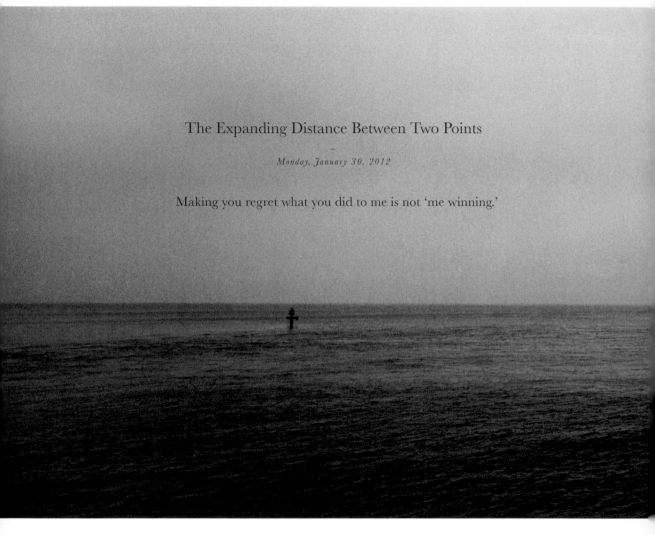

The Expanding Distance Between Two Points

–

Monday, January 30, 2012

Making you regret what you did to me is not 'me winning.'

It's everyone still losing.

The Well Of Dreams

Thursday, July 30, 2009

To wake up next to you. And confirm that the images I saw on the back of my eyelids seconds before, have all been made real.

The Mechanics Of Puppetry

Thursday, October 22, 2009

I guess I should say thank you, for cutting all my strings. But if it's all the same to you, I wish you'd left my wings.

The Church Of Broken Things

Tuesday, March 15, 2016

A part of me wants to break the things you're worried about breaking.

Because I want you to see that broken things are nothing to worry about.

The Breaking Of People

Thursday, January 5, 2012

You can try being broken and you can try forgetting. All I know is I am no longer broken about the things I have forgotten.

The Way We're Measured

—

Tuesday, November 6, 2012

My worry is that what you measure yourself
with ends up defining you. You pour yourself
into the thing that measures you and it defines
you. And I just hope that one day you find out
that you're fuller when you measure yourself in
love and people and moments, instead of things,
adoration and money.

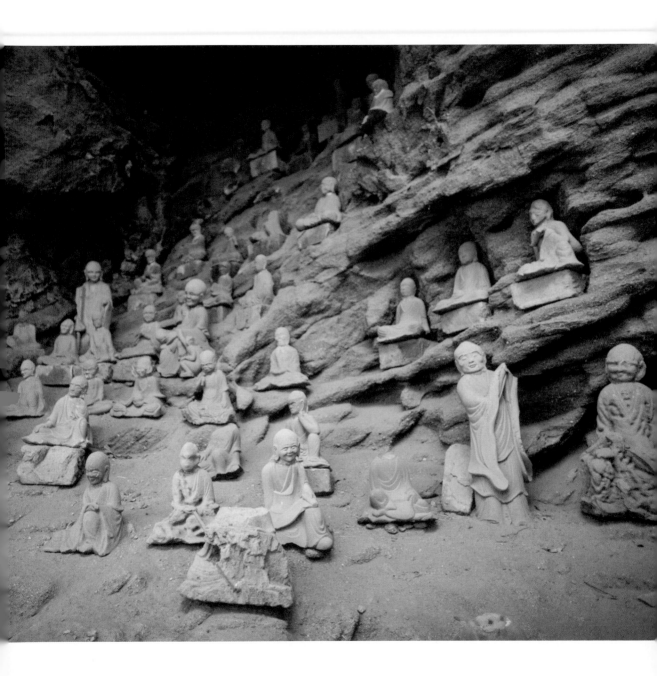

The Cage Holds A Rare Blue Sun

Monday, August 11, 2014

If you find them, tell them all you have said
and heard before you found them.

Tell them what rules you invented for yourself
along the way. Explain how you could never
do certain things and how jealous you are of
them, for being able to do them.

Tell them how happy you are that now, you
can do those things, because they're there.

Tell them about the first thing that made you
smile and the last thing that made you cry.

If you find them, tell them everything.

The Lights We All Once Were

Monday, October 3, 2011

There is no pain.

Just atoms becoming humans and picnics,
lovers and stars. And then something else.
And sometimes it feels like if the wind blew
too hard, it'd take us all with it. You don't
have to close your eyes. There is no pain. Just
molecules becoming the blood that pumps
through your heart and the knot in your
throat, the clouds above us and air inside your
lungs. There's nothing to cry about. There is
no pain. Just the light from distant suns and
flocks of birds. The sensation of time passing.
Waves against the sky. Those shudders than
run through your body, aren't there. Your nose
isn't blocked.

There is no pain.

The Coldness Of Earth

—

Thursday, October 28, 2010

And now you're with someone else and I must go home, alone,
to think about how long it takes to heal an alien heart.

The World Leaning On Your Shoulder

—

Sunday, February 14, 2010

You know all their stories but none of their stories know you.

And you've felt all their pain but their pain has never bothered feeling you.

So you take their medicine. Even though you've had too much medicine.

The Carrington Event

–

Thursday, May 3, 2012

Love proudly. Let it burn
anything between you.

The In-Between Things

Monday, November 2, 2015

For a second, the wind blew so
hard, it took the rain's breath
away and it could not fall,
and you had the only hand I
wanted to touch.

The Shipwreck In My Head

Monday, March 1, 2010

Everything you do, you pay for. So if
you're going to kiss me, you'd best be
prepared to bleed.

The Endless Night And All It Promises

Monday, June 4, 2012

We can be beautiful and new forever. Give me forever and I'll prove it.

The Misconception

Thursday, September 4, 2008

This was never meant to be about you.
It was meant to be about you realising
that it's all about the people around you.

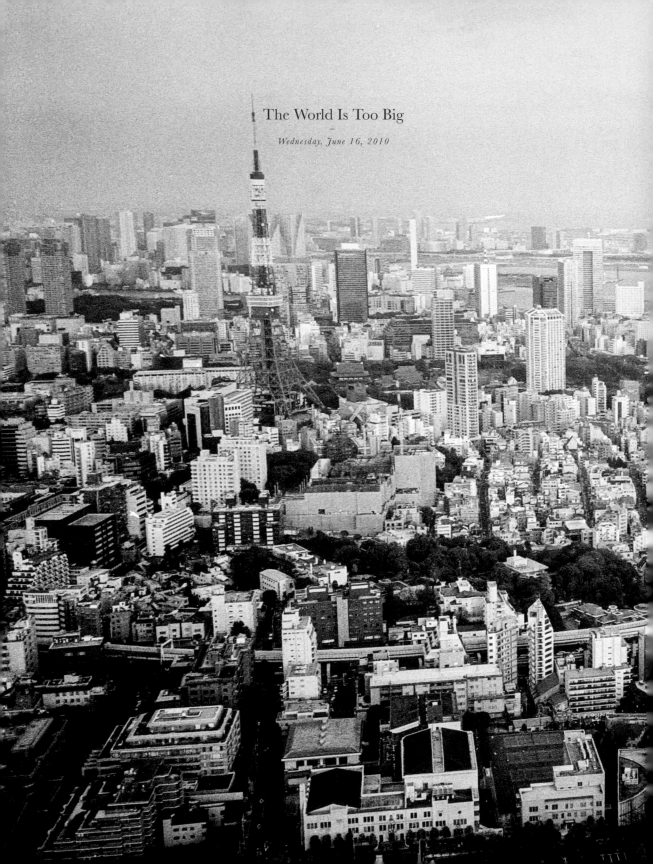

The World Is Too Big
—
Wednesday, June 16, 2010

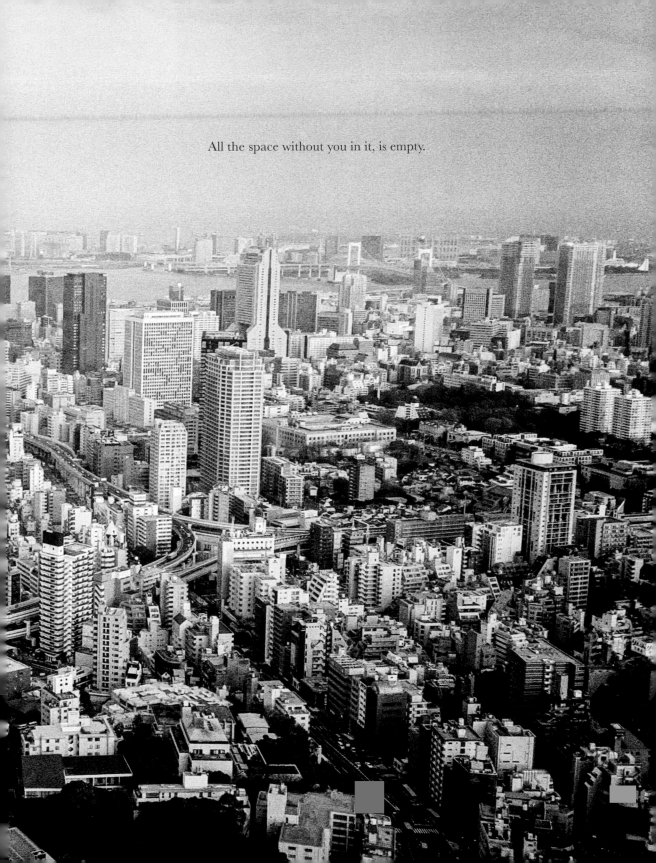

All the space without you in it, is empty.

The Truth Is Born In Strange Places

Thursday, August 5, 2010

Joan of Arc came back as a little girl in Japan, and her father told her to stop listening to her imaginary friends.

Elvis was born again in a small village in Sudan, he died hungry, age 9, never knowing what a guitar was.

Michelangelo was drafted into the military at age 18 in Korea, he painted his face black with shoe polish and learned to kill.

Jackson Pollock got told to stop making a mess, somewhere in Russia.

Hemingway, to this day, writes DVD instruction manuals somewhere in China. He's an old man on a factory line. You wouldn't recognise him.

Gandhi was born to a wealthy stockbroker in New York. He never forgave the world after his father threw himself from his office window, on the 21st floor.

And everyone, somewhere, is someone, if we only give them a chance.

The Light That Shines When Things End

Wednesday, March 12, 2014

I hope that in the future they invent a small golden light that follows you everywhere and when something is about to end, it shines brightly so you know it's about to end.

And if you're never going to see someone again, it'll shine brightly and both of you can be polite and say, "It was nice to have you in my life while I did, good luck with everything that happens after now."

And maybe if you're never going to eat at the same restaurant again, it'll shine and you can order everything off the menu you've never tried. Maybe, if someone's about to buy your car, the light will shine and you can take it for one last spin. Maybe, if you're with a group of friends who'll never be together again, all your lights will shine at the same time and you'll know, and then you can hold each other and whisper, "This was so good. Oh my God, this was so good."

The Words On The Tombstone

Friday, November 16, 2012

Do practical things if you want your tombstone to read,

"They were practical."

Do what makes sense if you think it should say,

"Their life made sense."

Do what the world wants if you believe in the epitaph,

"They did what the world wanted them to do."

But if you want it to read,

"They lived every second they were given and touched the sky every chance they had, they burned and blazed in all the colours the eye can see and left a hole shaped like them in the world when they left."

Then do something else.

The Fact That I'm Just Not Perfect

Friday, November 25, 2011

(The highways are filled with the dead inside.)

The highways are filled with people on their way to other people.

(Look at the way they're looking at you with glassy eyes.)

Look at how lonely they are and desperate for another human.

(The world needs to be burned down. Look at the news.)

The world is filled with beautiful people. Look at the news.

(Never apologise.)

I'm sorry.

(I am me.)

No.

You're not.

The Desire To Live Underwater Forever

Friday, July 13, 2012

If I breathe you in and you breathe me out, I swear we can breathe forever. I swear I'll find summer in your winter and spring in your autumn and always, hands at the ends of your fingers, arms at the ends of your shoulders and I swear, when we run out of forever, when we run out of air, your name will be the last word that my lungs make air for.

The Singe

Wednesday, November 21, 2007

Burn through.
Become the light.
You are not yet done.

The Place You Used To Live

—

Thursday, July 16, 2009

There's still a door here shaped like you.
Boarded up, covered in chains and nails with
paper stuffed in the locks.

The Mouth Moves But No Sound Comes Out

—

Monday, March 10, 2014

"You know I'm not really here, right?"

"Can I talk to you anyway?"

The Fate Of Those Born In Dirt

Monday, June 9, 2014

When I end, I will end as a tree ends:
as a fire, bleeding out the sunlight
from every summer it lived.

The Proven Regret

Tuesday, December 2, 2008

There are days when I exist simply to
prove you wrong about me.

The Series

Tuesday, November 13, 2007

There are moments of such pure,
sublime, unparalleled perfection that
they will force you to close your eyes and
hold on to them as best you can.

Life is a series of these moments.
Everything else is just waiting for them.

The Monsters I Miss
—
Monday, November 15, 2010

And every single thing you ever
did that bothered me, is every
single thing I miss.

The Voice In The Back Of My Heart
—
Friday, March 30, 2012

When you have nothing left to say to me,
say it anyway.

The Cold Travels Fast
—
Thursday, October 15, 2009

We all know what's happening here because it's happened before. Like
an avalanche, there's nothing we can do about it so we don't even need
to speak. But this time, if we're covered by the ice and snow, I will hold
you tight. I will keep you warm.

The Point Past Peak Feelings
—
Tuesday, March 8, 2011

I know you have feelings left somewhere.
But they're all so hard to reach.

The Green Curtain
–

Sunday, December 12, 2010

How many hearts would be invaded for the wrong reasons, if each time you said "I love you," you meant it?

The New Strangers
–

Tuesday, August 4, 2009

We could leave. We could go anywhere. Everyone talks with an accent somewhere.

The Future Of Text Books
–

Tuesday, November 8, 2011

Should any child be reading this in a history book, you should know that we loved. I hope that hasn't changed.

The Shock Of Honesty

—

Tuesday, March 30, 2010

Scare the world: Be exactly who you say you
are and tell the truth.

The Way It Isn't

—

Wednesday, January 14, 2009

I need you to give me the chance to take you
for granted.

The Stuff Of Science And Comets

—

Monday, January 5, 2009

Someone you haven't even met yet is
wondering what it'd be like to know someone
like you.

The Occasional Silence

—

Thursday, August 20, 2009

You can walk into a room and spot them. They seem fine when you talk to them but every now and again, across the room, you catch them looking off into the distance at an invisible point that maybe, they once reached. They laugh a little different. They hesitate a little more. Now they know what it feels like. And something about their eyes when they listen to music says,

"Turn it up until my ears bleed. Let it be the last thing I hear."

The Pressure To The Wounded

–

Tuesday, January 13, 2009

You know I just wouldn't be human if I didn't try and hold your hand as it disintegrated from the light of a thousand suns somewhere above Hiroshima. Or kiss the tears from your cheeks in Iraq, like the sweat from your brow in Zimbabwe. It isn't in me not to try and lift the rubble crushing you in Gaza or hide you in Rwanda. Like a last hug in a building in New York or the water we shared in Afghanistan. More than the blood we mixed in Flanders or the sandy beach we trod in Normandy. Longer than the fires burned in Dresden or Soweto. I won't let go of your hand.

The Day You Shot Me In The Back Of The Head

—

Friday, February 17, 2012

The sun rose like it does on any other day, on the day you shot me in the back of the head.

I'd just made coffee and you'd come back from doing the groceries and I asked if you wanted some without turning my head to look at you, on the day you shot me in the back of the head.

And I hit the floor so slowly and so hard and without any real warning, on the day you shot me in the back of the head.

I knew we'd had our differences and our silences but I didn't expect it to end like this, on the day you shot me in the back of the head.

I thought there'd be more time, on the day you shot me in the back of the head.

If I was still alive at that point, I imagine I'd smell cordite and sulphur filling the room and hear the echoes bouncing off the walls, on the day you shot me in the back of the head.

I imagine there was a look of surprise on my face, on the day you shot me in the back of the head.

I wonder if you thought you were being merciful by waiting until I wasn't looking, on the day you shot me in the back of the head.

I probably stared off at a distant point, while you gathered your things together and left, on the day you shot me in the back of the head.

And I know that my body was there for a while and that the room was dark and that it was very quiet, because of what you'd done, on the day you shot me in the back of the head.

But what you might not know, is that I got up.

And washed my face.

And the sun rose again.

On the day after you shot me in the back of the head.

The Celestial Companion

—

Thursday, April 29, 2010

Still, courage, my friend.

Still, all is not lost and you are not yet done.

Still, there are fires to burn in the darkness and light to cast amongst the shadows.

Still, there are moments that must be taken, fighting and spitting to the ground.

Still, nothing has killed us yet.

Still, the sky smiles on the brave.

Still, have the strength to try and hold the sun in the palm of your hand, once more.

Still, ever burning.

Still, the most beautiful things come from beneath the ground.

Still, the light is cast from the darkest of places.

Still, we labour on under the cover of stars.

Still, we know the truth rides high in our chests.

Still, the world has yet to end, no matter how hard any of us try.

Still.

Until we are still.

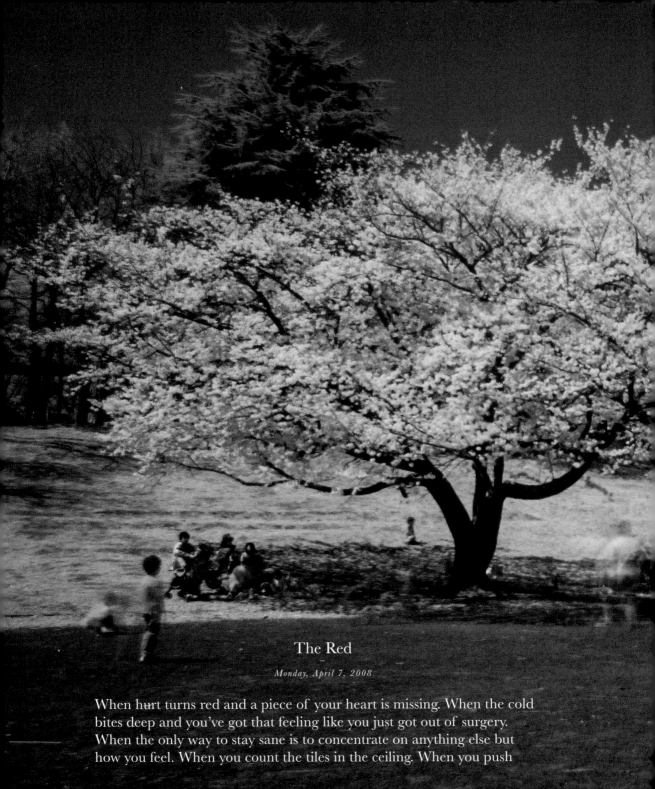

The Red

Monday, April 7, 2008

When hurt turns red and a piece of your heart is missing. When the cold
bites deep and you've got that feeling like you just got out of surgery.
When the only way to stay sane is to concentrate on anything else but
how you feel. When you count the tiles in the ceiling. When you push

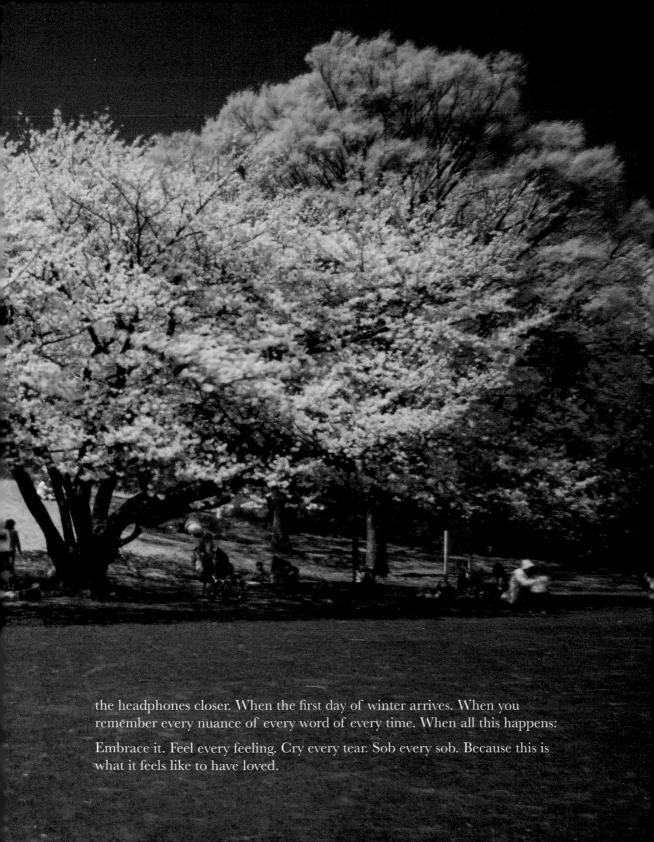

the headphones closer. When the first day of winter arrives. When you remember every nuance of every word of every time. When all this happens:

Embrace it. Feel every feeling. Cry every tear. Sob every sob. Because this is what it feels like to have loved.

The Corner Of Me & You

–

Thursday, September 10, 2009

I don't know if you felt that or not.

But it felt like two people kissing after hours of thinking about it.

It felt like two people talking after nights of silence.

It felt like two people touching after weeks of being numb.

It felt like two people facing each other after months of looking away.

It felt like two people falling in love after years of being alone.

And it felt like two people meeting each other, after an entire lifetime of not meeting each other.

The War Against The Sea

Thursday, January 12, 2012

You say that only a fool believes that everyone has some good in their heart.

You say that only a fool makes music in their mind.

You say that only a fool loves hate back.

You say that only a fool leans against the wind.

You say that only a fool takes on a planet.

You say that only a fool holds out hope.

You say that only a fool tries to fly.

You say that only a fool fights the sea.

Very well.

I am that fool. And I will die fighting.

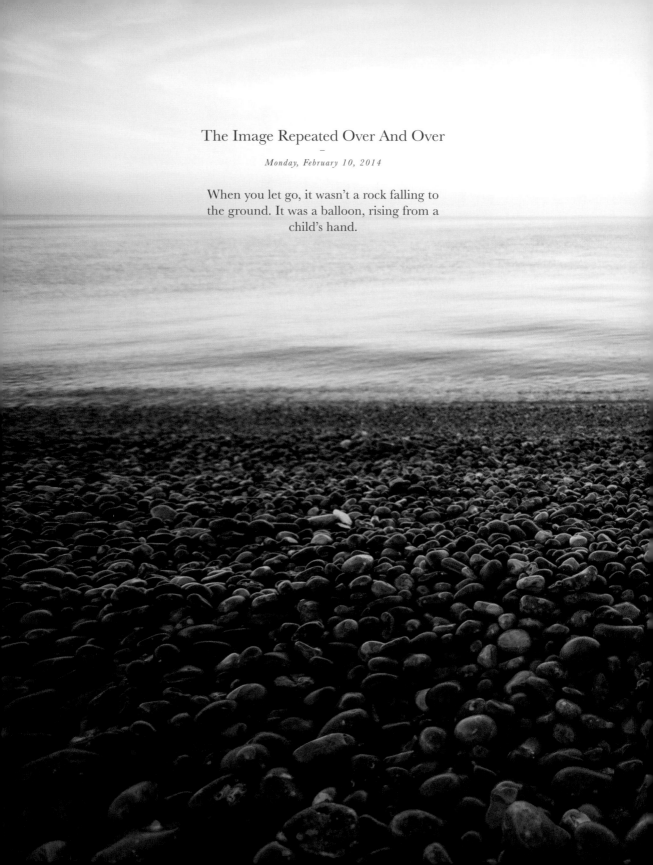

The Image Repeated Over And Over

—

Monday, February 10, 2014

When you let go, it wasn't a rock falling to
the ground. It was a balloon, rising from a
child's hand.

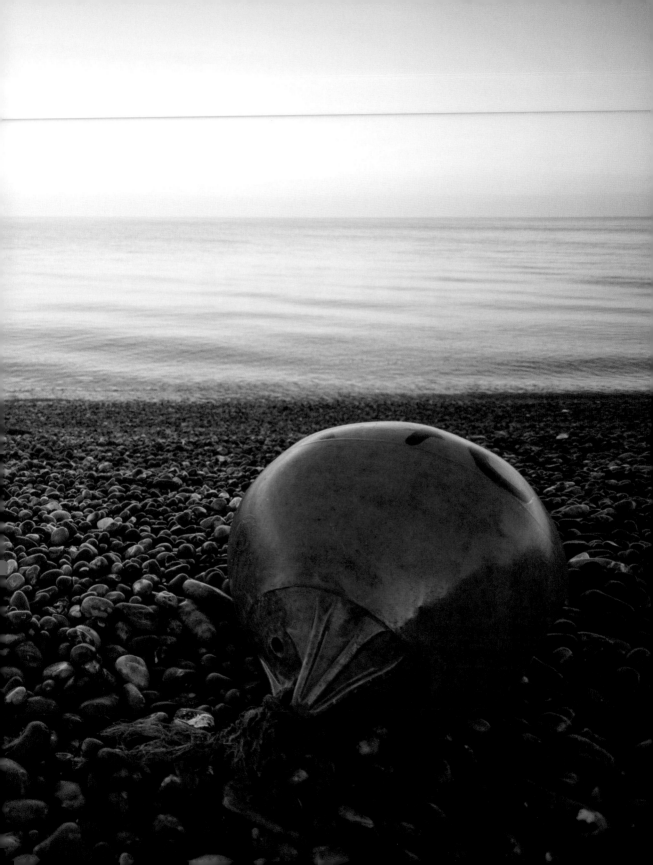

The Shape In The Mirror

—

Thursday, January 12, 2017

DO YOU REMEMBER WHEN I WAS GOOD AT MISSING YOU?

The Safety Of Death

Friday, January 16, 2015

Death isn't when your heart stops.

Death is when you give up who you
could be for the safety of who you are.

The Two Player Game

Monday, October 6, 2008

I picked up my pieces so I could help
you pick up yours.

The View On The Way Down

Monday, March 2, 2009

All the hardest, coldest people you
meet were once as soft as water.

And that's the tragedy of living.

The Big Blue Sea

Sunday, September 28, 2008

I don't care how many fish there are in
the sea. I don't want a fish. I want you.

The Remaining Mirrors

Friday, May 18, 2012

And I hide because there's more to
me than what you see and I'm not
sure you'd like the rest. I know that
sometimes, I don't like the rest.

The Ignored

Saturday, September 15, 2007

You are constantly surrounded by
incredible beauty wherever you go.
Stop. And look around you.

The Missed Appointment

Friday, June 26, 2009

So yes, we could kiss. I could kiss you and you could kiss me. There's no science,
plane ticket or clock stopping us. But if we kiss, it will end the world. And I've
ended the world before. No one survived. Least of all me.

The Tomb Of The Unknown

Thursday, February 10, 2011

I never fell in love with you. I just fell.

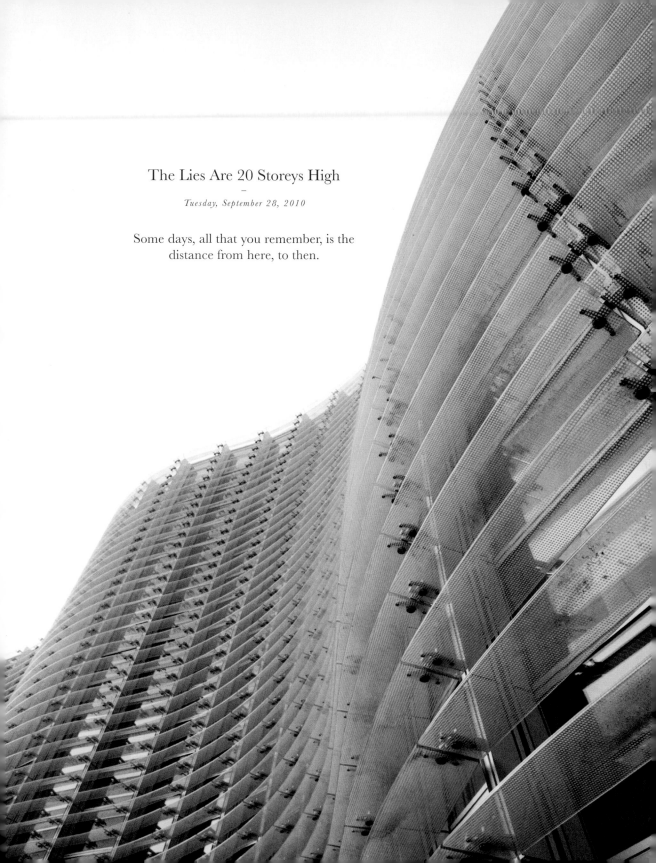

The Lies Are 20 Storeys High

–

Tuesday, September 28, 2010

Some days, all that you remember, is the
distance from here, to then.

The Rain Of Black Umbrellas

Monday, May 9, 2016

I'm not saying I know you better than
anyone else.

I'm saying I know better than anyone
else what it's like to miss you.

The Static On The Line

Thursday, February 25, 2010

Don't talk to me like you know me.
Talk to me like you love me.

The Heart Rides On

Friday, November 20, 2009

I love you. I love your eyes. I love your smell. I love your hair. I love your laugh.
I love your skin. I love everything inside you. And I'll try to make all the parts
that I find, happy.

Because you make me happy. So much.

The Heart Beats Per Minute

Tuesday, March 17, 2009

You are the best parts of all the songs I love.

The Infinite Distance

—

Thursday, May 31, 2012

Your poetry is lonely. And yet, you write to feel less alone.

The Messenger Was Dead When I Got Here
—
Monday, June 28, 2010

You should tell them the truth. Tell them that if they hold on too tightly,
love might cut them. Tell them to hold on tightly anyway. Tell them
everything is worth it and that the richness of life is only ever enhanced by
its inevitable, brief flashes of sadness and loss.

The Slow, Gentle Continental Drift
—
Sunday, January 31, 2016

I stayed because you were the only one
who thought I could be better.

I stayed so that you could get better.

I stayed.

The Reflection In Shop Windows
—
Thursday, June 19, 2014

If you live in your head for too long, you run
the risk of becoming your own secret.

The Station
—
Friday, August 29, 2008

Fuck it. You throw a dart at a map, we'll go there and start new. Somewhere
else in the world that's not here. Somewhere where we haven't said things to
each other that we can't unsay and done things which we can't undo.

There we can say new things. We can do new things. And those new things
we say and do will be more important than the old things. Let's leave. Please.
Leave with me.

The Rose Is Not Always A Rose
—
Wednesday, June 10, 2009

You can be in love and you can be in
a relationship. But they're not always
the same thing.

The World You Cannot Fly In
—
Monday, May 3, 2010

They've taken us from the edge of the sky (where the sky is just our reflection, looking down) and brought us here, my love. I can no longer breathe and you, you and the world have begun to melt and fade.

They've taken us, my love, in their cruel nets and crude boats to their own dark sky.

They think us ugly. But we are not the ugly ones here.

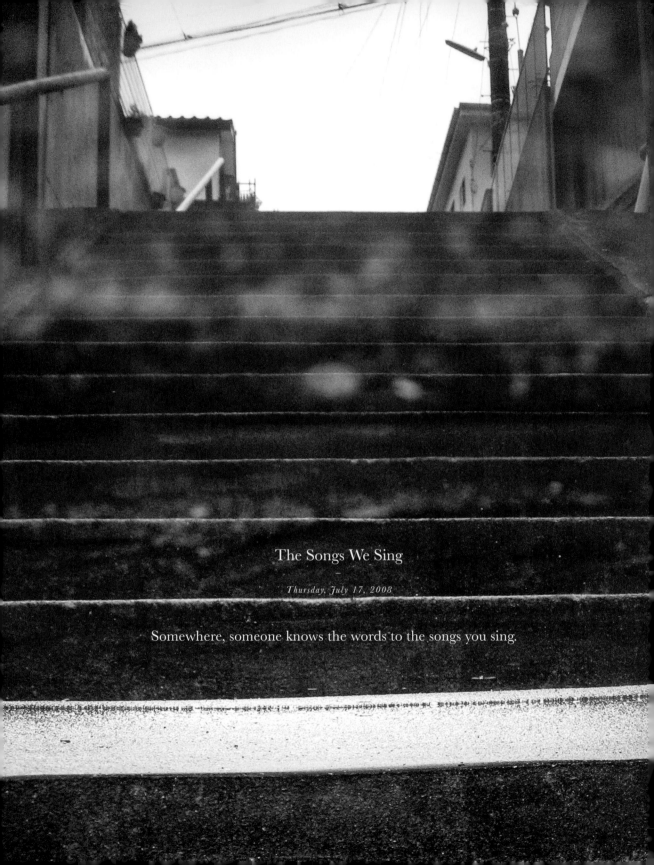

The Songs We Sing
—
Thursday, July 17, 2008

Somewhere, someone knows the words to the songs you sing.

The Cupboard Is Empty

—

Thursday, January 1, 2009

I'm all out of midnight phone calls and flowers
sent to your door. I'm out of throwing letters
off fire escapes and drawing a cathedral in the
sand. I'm out of spray-painting your name on
freeway overpasses. I'm low on cute names
given between blankets and 9am. I've got no
dramatic displays of public affection left. And
now everyone else I ever love is going to think
me boring. Because I used it all up on you.

The Skyscrapers Meet By The Side Of The Road

—

Thursday, March 26, 2009

We look at the people who tell the truth, who
say real things in public, like they're confused.
Crazy. As if everything should be said safely
or not at all and what you feel shouldn't be
taken seriously.

Which is why it's not polite to say, "I'm going to
kiss you now because I can't do anything else."

The Start Of Stupid Stories

Thursday, February 9, 2017

I believe that if you're good, more good things happen to you.

I believe it rains to let you know you're lucky.

I believe that you only get old if you let yourself.

I believe in trying your best and forgetting who you are as often as possible.

I believe that there's a way to love someone like we thought we could love when we were young.

I believe there's a way to love like a story book.

I believe in stupid things.

The Chance To Disappoint You

Thursday, March 19, 2015

I love you.

So let me disappoint you.

Because I know that if you love someone, you are opening yourself up to being disappointed by them.

Because how can you love someone as a human, without everything that comes with that.

So disappoint me.

Disappoint me constantly, with all that you are and all that you could be and with everything that makes you, you.

I promise to disappoint you, with my whole heart.

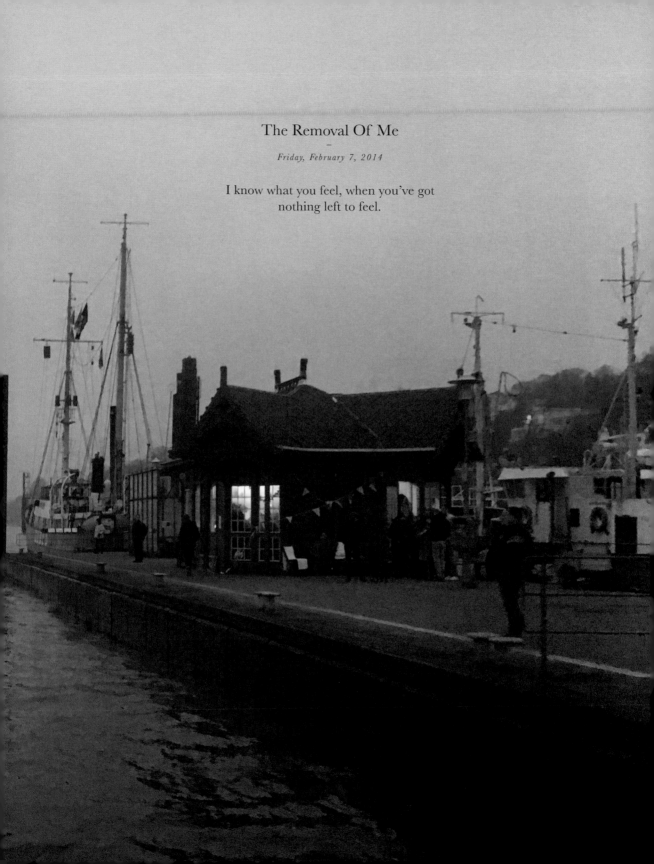

The Removal Of Me

—

Friday, February 7, 2014

I know what you feel, when you've got
nothing left to feel.

The Strangest Days

Thursday, March 15, 2012

And when I'm far from home and I feel like an alien, trust me, somehow I never left you.

The Night Is A Tunnel

Tuesday, December 18, 2012

I have told the sky all my loneliest thoughts of you. And all it does is shine starlight back at me. But I guess that's what makes it such a good listener.

The Impressions On Snow

Thursday, March 10, 2016

It can be hard to convince yourself that the things you feel aren't real. But in order to actually interact with the world, sometimes you must act as if you don't feel them, at all.

The Needle And Ink

Monday, July 13, 2009

Look at you, like a new tattoo. Because I might not always have you but I'll have the feeling of you for the rest of my life.

The Grasping Of Stars

Tuesday, December 13, 2011

They'll tell you that you're the ground.
Remember that you hold up the sky.

The Send/Delete

Wednesday, August 6, 2008

I've written you a hundred messages
that I'll never send.

The Spider Silk

Monday, March 7, 2016

Choose good friends if you want to stop growing old.

Whenever they see you, no matter how many years it's
been, they will look at your face and say,

"Look at all the things you've done.

Look how beautiful you've become."

The Billions Of Pieces

Friday, February 10, 2012

The human heart is made from the
only substance in the universe that can
become stronger, after it's been broken.

The Sound Of Stars Exploding

Wednesday, August 19, 2015

I am asking you to listen to the promise in the
static on the radio or the scratches on a record:

There is a chance for something not quite
perfect to happen here tonight.

The World Needs More Lighthouses

Friday, April 9, 2010

You can join the millions talking in the
dark. Or you can stand up and scream
light, out into the night.

The Thing That'll Kill You Is Being Afraid

—

Friday, October 24, 2014

Never leaving your house, will kill you. Staying where you are and being afraid, will kill you. Pecking at the new notifications icon on your social media platforms of choice, cycling through them like a series of surreal fridge doors that might contain something better since you last looked, this is what will kill you second by second until you realise you have none left. You are far more likely to die from fear and apathy, from not having lived and fulfilled the multitude of promises that you make yourself each night before you fall asleep, than anything else.

The Tender Tinder Box

–

Sunday, November 22, 2009

You've made the air flammable.
These walls are just paper. And
blood is gasoline. You shouldn't
have come here, made of
fireworks, if you didn't want me
to play with fire.

The Shape Of It

—

Friday, June 19, 2009

They want me. I want you. And you
want someone else. But none of us
want to turn around.

The Bridge From Solitude

—

Thursday, July 9, 2009

Just like you mistook lust for love, you have
mistaken being alone with loneliness. So
I'm fine. Thank you for asking.

The Ghost Ships

—

Monday, February 2, 2009

I won't keep circling the ocean forever, hoping I'll spot your island on the
horizon, un-colonised and flying an old, tattered flag. You on the shore with the
sand between your toes.

The Blind Corner Waits

—

Friday, July 10, 2009

I just move my lips and my tongue and
breathe and the sounds are made. But still, I
do not say "I love you" easily.

The Shot Stars

–

Wednesday, February 15, 2012

If your star falls down, you will
find mine lying beside yours.

The Snow Falls On Forever (Hush)

—

Monday, January 16, 2012

You can't miss forever.

No matter how close forever
feels right now.

You can't hurt forever.

Even if your heart whispers in
your ear and tries to convince
you otherwise.

You can't bleed forever.

Sooner or later, you will either
die or live.

Neither of us can do anything
for forever.

Because forever passed away,
long ago.

The Whispering At The Back

—

Monday, January 18, 2010

You say the things you don't need to say.

Because it hurts when you don't say them.

The Lost And Unfound

—

Monday, January 9, 2017

I said, "I hope you find who you're looking for."

I said, "I hope you find someone to hold your heart."

Even though I thought I was the one you were looking for.

Even though I thought I could hold your heart.

The Past Keeps Going Away

Thursday, September 13, 2012

After you're gone, people will forget your name, no matter how important it was, and your face, no matter how pretty it was, and what you said, no matter how clever any of it sounded.

The things you've done will crumble and fade and the places you once loved, will change and be given new names.

You are only here for one moment and it lasts exactly one lifetime.

The Light Leaving Machines

Wednesday, January 20, 2016

I will record it, and when the time comes for me to die, I, or the nurse, will put the earphones in and I will hear:

"You have a name but soon you will not.

You loved everyone you could as much as you could.

You are only doing the most natural thing in the world.

Everything, is fine."

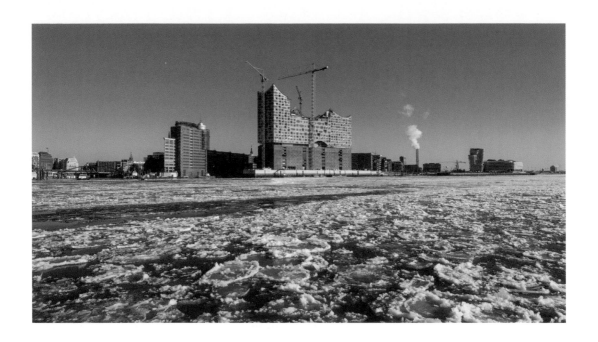

The Light From Frozen Graves

—

Friday, February 3, 2012

"But I just want to stop feeling."

"As far as I can tell, there's only one way to stop feeling and that's to die."

"That seems a bit drastic."

"It is drastic. Perhaps the most drastic thing there is. There are other ways to kill feelings, like drinking a lot or working hard, constantly, pushing those around you as far away as possible until there's no way for you to reach out to them but ultimately, the only way to completely stop feeling, forever, is to die."

"I'm not sure I'm ready for that."

"Good. You'll be a better person for it."

"What do you mean?"

"I mean that the most interesting, amazing people I've ever met, the ones who influenced and shaped the universe itself, are the ones that felt too much but lived through it."

"That sounds hard."

"It is. It involves living."

The Violent Peace

–

Monday, February 20, 2012

You kill death every day that you live.

And I do my best to murder hate whenever I have the chance to love.

The Coming Wave

—

Thursday, May 12, 2011

You break upon the shore. I will rise
with the tide.

The Truth Is Ugly

—

Monday, March 22, 2010

In the movies, the person leaving you never
has a blocked nose when they cry. And all
their tears are pretty.

The Language Of Stars

—

Tuesday, January 17, 2012

Love:

To discover there's at least one other real person on planet Earth.

Loss:

To discover that the aliens, can look just like you.

The Do Over

—

Tuesday, July 1, 2008

You decide every moment of every day who
you are and what you believe in.

You get a second chance, every second.

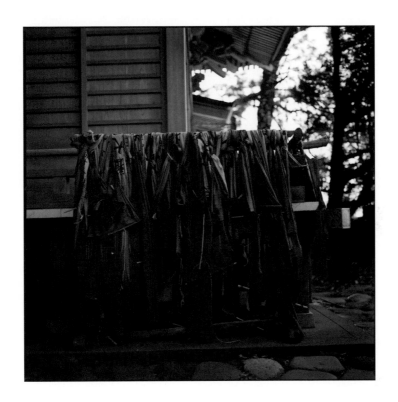

The Scars You Love
–
Monday, December 15, 2008

There are a million ways to bleed.
But you are by far my favourite.

The Salting Of The Earth

—

Tuesday, April 10, 2012

You should know that there is something worse than hate and that is unlove.

Because hate is anger over something lost, hate is passion, hate is misguided, it's caring for the wrong things but it is still caring.

But unlove, unlove is to unkiss, to unremember, to unhold, to undream, to undo everything that ever was and leave smooth stone behind in its wake.

No fire.

No fury.

Just, nothing.

And that is worse than hate.

The Roar Of The World

Tuesday, June 28, 2011

And while it may feel like you're
in a stadium, in front of a crowd
screaming that you must die, there
are voices in that crowd, if you listen
closely, screaming for you to live.

The Unnoticed, Noticed

Monday, February 21, 2011

You notice someone cutting you off in
traffic but not that the Earth is still here for
one more day.

The End Bit Is Animated

Thursday, March 19, 2009

We help people when big things happen to them, when you see them getting
hit by a car, when a brother or a sister or a father or a mother dies, we're there
for them because we can see that death kills more than the person it takes. And
yet, the people around us who die a little all the time, moment by moment, who
require the least help, the smallest sacrifice, are the ones we ignore completely.

The Turning Of A Sphere

Tuesday, May 10, 2016

Who could I love now?

Surely, you were both the start and the end of
the world.

The World Whispers Songs Softly

—

Tuesday, February 18, 2014

At the end of everything, they'll pull
you up and whisper in your ear,

"Could you hear the music?"

And so many of us will have no idea
what they mean.

The Words You Lost Between Cushions

—

Monday, July 20, 2009

I'll pretend that you mean the
weather when you ask me how things
are. I'll say cold.

The Saying Of When

Thursday, June 18, 2015

When you love like the last good thing.

When you love and forget every
important thing you were going to say.

When you love and forget everything.

The Wry Catcher

Thursday, January 28, 2010

If sadness is what happens when
you turn your anger inwards, hope
is what happens when you turn your
happiness, outwards.

The Truth Is Different Every Day

Wednesday, March 14, 2012

You keep trying to tell
the truth about who
you are but you keep
changing, every time
someone listens.

The Sun Or The Moon

—

Thursday, February 26, 2009

Things change the way you feel.
And things change.

The Cold Reflection

—

Wednesday, February 19, 2014

Never complain that you haven't been given
things to say.

One day the world will destroy itself, and you will
drown in the words you didn't think you had.

The Illusion Of Things Never Changing

—

Monday, November 24, 2014

You think, "This is life, this is just how it is and how it'll always be." But you are living
through something. And while, logically, you must know that there was a time before
now, when things were different, and that there will be a time after now, and things
will change, it's so hard to remember right now: Everything will change.

You are alive in a memory.

You, are once upon a time.

The Tales From The Bar

—

Tuesday, September 22, 2009

You're just another story I can't tell anymore.

The Person Happiness Became

–

Sunday, March 29, 2009

So if you love me but you don't need
me, you don't love me.

The Floor Takes So Long To Hit

–

Wednesday, April 14, 2010

Congratulations. You took me down.
And now, you have made everything
that is sad, relevant.

The Things I've Never Seen Or Heard

–

Saturday, January 24, 2009

I honestly couldn't care less if you like the same bands or you've
read the same books. Tell me one original thing, tell me one true,
real thing that brings me to my fucking knees that I've never heard
before and I'm yours.

The Manic Iridescent

–

Thursday, July 2, 2009

It's too easy to lose your mind when you lose
your heart. That's why love is madness.

The Fragments Of Hope

—

Tuesday, May 11, 2010

Dear Future You,

Hold on. Please.

Love,

Me.

Dear Current You,

I'm holding on. But it hurts.

Love,

Me.

Dear Past You,

I held on. Thank you.

Love,

Me.

The People We Could Be
–
Monday, January 11, 2010

Being gifted doesn't mean you've been given
something.

It means, you have something to give.

The Defect At The Heart Factory
–
Wednesday, February 8, 2012

There is no heart you can have that another
heart will not have a problem with.

The Traveller
–
Tuesday, March 4, 2014

I am just the hand you touch when you reach for the air, I am just the
nerve signal, moving along the wires in your body, I am just trying to
reach your heart to make it beat, one more time.

The Frozen Heart Of A Comet
–
Wednesday, August 5, 2009

You became what you thought everyone
wanted you to be. But that's not who you are.
And that's who I wish you were.

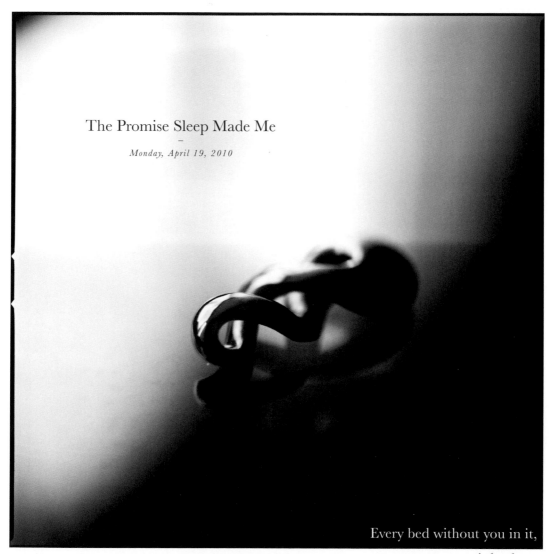

The Promise Sleep Made Me
—
Monday, April 19, 2010

Every bed without you in it,

is broken.

The Theory Is Still Just Theory

Wednesday, May 12, 2010

And if I blink my eyes enough, maybe I will
wake up and you will still be there sleeping
next to me.

The Rule

Wednesday, June 3, 2015

Here's what you don't say, "I sometimes wonder if the universe is a movie and if it's really all about me."

You don't say, "I am still competing with everyone I competed with as a child."

Or, "I fall in love a little with everything."

You never say, "I think everyone else knows something that I don't."

Or, "I can be distracted when you're not here, but not happy."

And don't ever say, "I just want you to cry like I cried."

You never say the most important things. That's the rule.

The Cold End Of All Things

Monday, March 13, 2017

"Even if you've forgotten who you are, you could at least try to remember what you mean, and who you mean it to."

"I think I've forgotten both who I am and what I mean. And why should I care? Why should any of us mean anything."

"You're just talking now. You don't have to talk if you don't want to."

"What is left to talk about? These are our lives and they have both begun and begun to end."

The Love Like Sunlight
Monday, April 7, 2014

I hope one day you get to love
someone like you love breathing
air or drinking water. Like they
are fundamental to your existence,
needed and necessary.

I hope you get to love like gravity
loves, like the sun loves the Earth.

Like warm sunlight upon soil that
makes plants grow.

I hope one day you get to love like
that.

The Beakers I'd Break

—

Thursday, September 24, 2009

And I'd study the science of you till I turned it
into an art. The way your atoms rub together.
Molecules colliding. Chemistry building.

Explosions of heat and radiation. Burning like a
star at the end of the world.

Be Soft.

Do not let the
World make you hard.
Do not let the
Pain make you hate.
Do not let the
bitterness steal your sweetness.
Take pride that even though
the rest of the world
may disagree,
You still believe
it to be
a beautiful place.